## HOW TO DRAW

# Landscapes

### A STEP-BY-STEP GUIDE FOR BEGINNERS WITH 10 PROJECTS

## IAN SIDAWAY

NEW HOLLAND

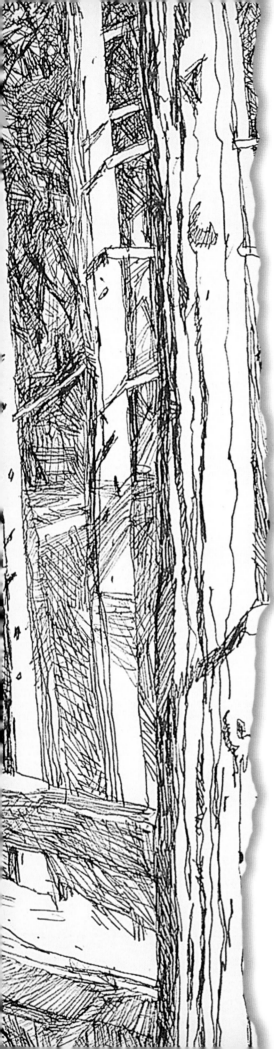

Reprinted in 2007
First published in 2005 by
NEW HOLLAND PUBLISHERS (UK) LTD
London • Cape Town • Sydney • Auckland

Garfield House
86–88 Edgware Road
London W2 2EA
www.newhollandpublishers.com

80 McKenzie Street
Cape Town 8001
South Africa

Level 1, Unit 4
14 Aquatic Drive
Frenchs Forest, NSW 2086
Australia

218 Lake Road
Northcote
Auckland
New Zealand

10 9 8 7 6 5 4 3

ISBN  978 1 84537 051 0

Senior Editor: CORINNE MASCIOCCHI
Design: BRIDGEWATER BOOK COMPANY
Photography: IAN SIDAWAY
Editorial Direction: ROSEMARY WILKINSON
Production: HAZEL KIRKMAN

Reproduction by Pica Digital PTE Ltd, Singapore
Printed and bound by Times Offset (M) Sdn. Bhd., Malaysia

NOTE
Every effort has been made to present clear and accurate instructions.
Therefore, the author and publishers can offer no guarantee or accept
any liability for any injury, illness or damage which may inadvertently
be caused to the user while following these instructions.

# Contents

Introduction  4

Tools and materials  6

Basic techniques  10

Demonstrations

**1** **Fields and trees** *Graphite pencil*  18

**2** **Mountains and cliffs** *Coloured pencils*  24

**3** **Distant peaks** *Pastel pencils and hard chalks*  30

**4** **Skies** *Charcoal pencils*  36

**5** **Winter landscape** *Charcoal and chalk*  42

**6** **Waterfall** *Conté*  48

**7** **Pine forest** *Fine liner*  54

**8** **Summer shore** *Pen and wash*  60

**9** **Coastlines** *Graphite sticks*  66

**10** **Volcano and rainforest** *Pastel pencils*  72

Suppliers  78

Index  80

# Introduction

For the artist, the landscape holds an endless fascination. The wealth of material and subject matter offers limitless possibilities that should keep even the most ardent artist absorbed in a lifetime of picture making.

It is easy to take the landscape for granted. Often, it is only noticed when it is no longer there, erased by the inexorable advance of our urban sprawl or devastated by natural disaster. Landscapes alter constantly, and the weather is an important factor that can change the quality and mood of the scene in a matter of minutes. The same landscape will appear radically different seen in summer sunlight, cloaked in a dense mist or covered in a deep layer of snow.

The landscape is one of the few subjects over which the artist has no immediate influence or control: nothing can be posed or arranged. The subject will make demands not only on your knowledge of technique but on the use of the principles and disciplines needed for good picture making, including the use of colour, tone, perspective and composition. However, all that is not to say that a drawing needs to be hopelessly complex or difficult to make. With practice, even just a few carefully and economically positioned lines can simply and effectively depict the scene before you.

Drawing landscapes can at first seem like a daunting prospect. Not only do topographical elements need to be considered, but often the rapid ever-changing appearance of the sky or the sea. But the artist need not concern his or

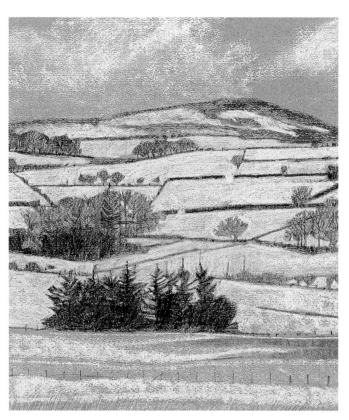

**ABOVE** Changes in the weather are important and can alter the appearance of a scene dramatically.

herself with the 'big picture' alone, since all landscapes consist of a myriad of smaller 'tableaux' and details, all of which can provide suitable subject matter for drawing.

When drawing landscapes, matching your chosen drawing materials to your subject pays huge dividends. You will find that trying to draw a tonally-complex panoramic view complete with a stormy overcast wind-blown sky using a dip pen and ink, whilst possible, is fraught with difficulty. Success is far more likely if a softer pigmented drawing material such as charcoal or graphite is chosen. Not only are both these materials suitable for representing tone but they are also capable of achieving a quick result – an important consideration when working in the sometimes less than favourable conditions that are to be found on location.

## Using the Book

The 10 projects featured in this book cover a wide range of drawing materials, techniques and subjects. Each project becomes slightly more complex and involved as you progress through the book. The lessons learnt while working through each project are cumulative, and what is learnt in one can be carried forward to the next. For this reason, the absolute beginner may find it more beneficial to work his or her way through the book. The more adventurous, however, can dip in wherever they please. In addition to the main drawing, each project features an alternative drawing of the same or similar subject, produced using a different drawing material – its purpose to illustrate further styles and treatments.

A photograph of an alternative set-up is also included for you to attempt your own treatment and variation without having to find your own subject on location. The treatments for each project are merely suggestions; the variations and possibilities are endless and this book acts only a starting point. Apply what you learn in this book to make your own drawings on location and you will find that your love and enjoyment of the landscape increases as you learn to analyze what is before you more clearly.

FINAL DRAWING

STEP-BY-STEPS

SUBJECT

ALTERNATIVE
DRAWING IN A
DIFFERENT MEDIUM

ALTERNATIVE
SUBJECT VIEW

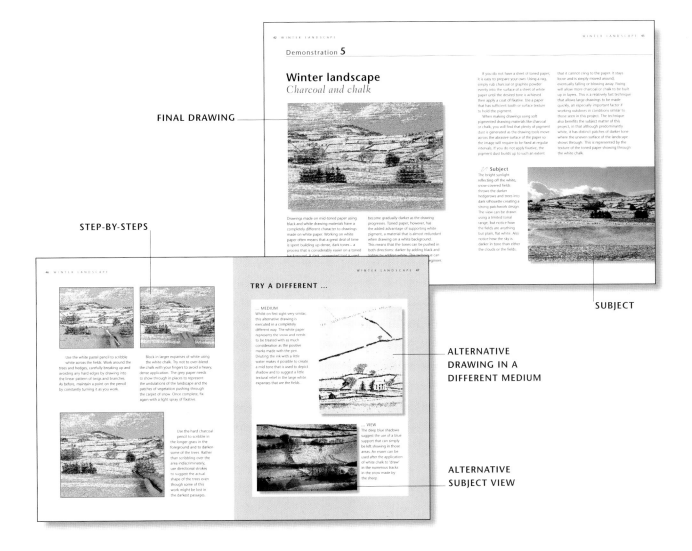

# Tools and Materials

This section describes the tools and materials used in the book. Refer to it when you are purchasing your equipment. Drawing equipment is, on the whole, relatively inexpensive and capable of producing many drawings before it needs replacing. The materials needed to start drawing are simple: a tool with which to make a mark and a sheet of paper on which to make it.

PENCILS  The drawing tool that is familiar to all is the 'lead' pencil. This is something of a misnomer as the pencil is not made from lead but a type of carbon known as graphite. Graphite pencils can be found in various degrees of hardness ranging from 9H the hardest, which makes a very pale grey line, down to F and HB. The grades then become softer running to 9B, the softest. Each grade of pencil will only produce a tone of a given darkness and no amount of pressure will make that tone darker. If you require a darker tone, use a softer grade pencil. B or HB pencils will give a full range of tones by varying the pressure applied. Clutch pencils can also be found that hold thin strips of various grade graphite in a barrel that also often incorporates a sharpener at one end. Pencils are best sharpened using a sharp craft knife.

PENCILS

GRAPHITE STICKS  are pencil-size solid strips of graphite. Some brands are encased in a thin plastic coating which breaks away as the stick is sharpened. The shape of the stick means that a large area of graphite is exposed, making it possible to use not only the point (for making fine line work), but also the side so that broad areas of flat tone are achieved. The sticks are available in HB, 3B, 6B and 9B grades. Graphite sticks should be sharpened with a pencil sharpener or by rubbing on fine grade sandpaper. You can keep the resulting powder and use it to rub on to drawings to create areas of tone. As with traditional pencils, barrels that operate with a clutch mechanism can be found that hold thicker, softer grade graphite strips. When using very soft, thin graphite sticks take care when pressing hard as the soft graphite snaps easily.

CHARCOAL  is made from carbonized wood (usually willow but beech and vine are also used). The sticks come as soft and hard media and in four thicknesses: thin, medium, thick and extra thick sticks. Compressed charcoal is harder and cleaner to use than traditional stick charcoal. This too is graded as to hardness and density and is made into pastel pencils with wooden or rolled paper barrels. Charcoal is best sharpened using a sharp craft knife or by rubbing against fine sandpaper. Drawings made using both types of charcoal should be given a coat of fixative upon completion to prevent the image from smudging.

ARTIST'S PENCILS, CONTÉ AND CARRÉ STICKS, AND CHALKS  There is a wide range of artist's pencils and Carré sticks available. These contain various traditional pigments including white, sepia, sanguine, bistre, terracotta and black. Drawings can be made using these singly or by combining one or more. The pigments are found as pencils with a round or flat profile or as short chalks or Carré sticks. Coloured Conté sticks and hard chalks or pastels are ideal for making coloured sketches. Available in a comprehensive range of colours, they work particularly well on coloured paper and can be used with other dry drawing media. The pencils are sharpened with a pencil sharpener and the sticks with a sharp craft knife or by rubbing on sandpaper. Some of these pencils have a wax content that enables them to be used without fixing. Other pencils are more chalky and will require fixative protection. While the pencils are more suitable for line work, the sticks can be used to block in larger areas of tone. Pencils and chalks are often used together.

COLOURED PENCILS AND PASTEL PENCILS
The pigment in coloured pencils is mixed with a clay filler and a binder. Wax is added to act as a lubricant and help the pencil slide smoothly over the paper. Coloured pencils do not need fixing whereas pastel pencils do. Made from a strip of hard pastel fixed in a wooden barrel, the pencil leaves a highly pigmented mark that is relatively loose and prone to smudging. Pastel pencils are especially effective when used on coloured paper and are best sharpened with a sharp craft knife. Avoid dropping the pencils as the soft pigment strip breaks easily.

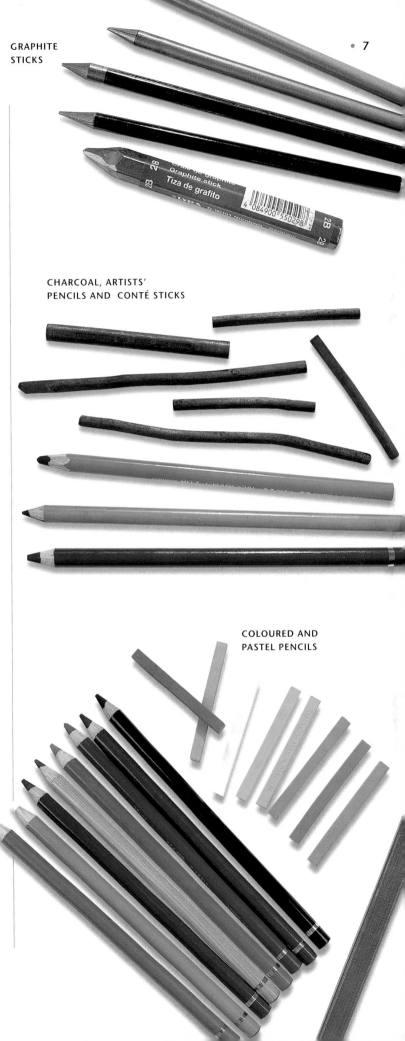

GRAPHITE STICKS

CHARCOAL, ARTISTS' PENCILS AND CONTÉ STICKS

COLOURED AND PASTEL PENCILS

SHARPENERS Wooden-barrelled pencils are best sharpened with a sharp craft knife to enable the point to be sharpened to the desired length and shape. Solid graphite sticks should be sharpened with a pencil sharpener.

ERASERS AND STUMPS Putty erasers are soft and malleable and can be shaped to erase precise areas. They do get dirty quickly when used with charcoal or chalk. Harder plastic erasers are better for this and are especially useful when used to make precise lines or textural marks in areas of tone. However, care must be taken with hard erasers not to distress the support. Art gum erasers are used for cleaning up large areas. They can be cut into small pieces so that when a piece is dirty, it can be discarded.

The paper stump or torchon is used to manipulate and blend loose pigment, pushing it into the paper's surface. As the stump becomes dirty, it can be cleaned by rubbing with fine sandpaper.

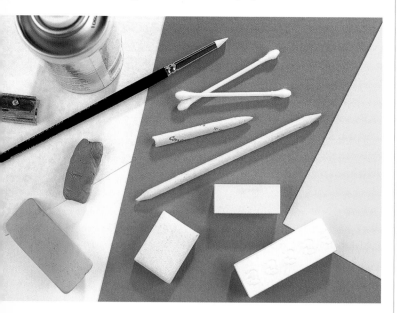

SHARPENERS, ERASERS, STUMPS, FIXATIVE, PAPER AND SUPPORTS

FIXATIVE Drawings that are made using soft pigmented drawing tools such as charcoal and chalk need to be fixed to prevent them from smudging. Fixative consists of small particles of resin suspended in a spirit solvent. Once applied, it evaporates leaving the resin particles to hold and bind the pigment dust to the surface of the support. Drawings can be fixed when complete or at various stages in between. However, once fixative has been applied, it will no longer be possible to make corrections or textural marks with an eraser.

DIP PENS AND INK Dip pen holders take interchangeable steel nibs in a range of sizes with pointed, round or square-cut ends. Certain nibs fit certain pens so try before you buy. Several nibs can be used in the course of a single drawing so you may need two or three holders. Occasionally, a new nib may seem reluctant to accept the ink so try rubbing a little saliva on to it.

Pens cut from a length of bamboo also vary in size and thickness. They are hard-wearing and ideal for textural work. Reed pens are similar but the cut nib is brittle and tends to break. However, they are easily recut using a sharp craft knife. Quill pens made from goose feathers will also need to be periodically recut. These are a delight to use and give a wonderfully sympathetic and expressive line.

Inks are either waterproof or non-waterproof. They can be diluted with water and non-waterproof inks can be corrected by rewetting. Perhaps the best known ink is Indian ink. This black ink is in fact from China and becomes a warm, deep sepia colour when diluted with water.

ART, BALLPOINT AND TECHNICAL PENS
Pens that use water-soluble inks are especially useful as it is possible to rewet areas to lighten the line work and pull out areas of tone. The main similarity with pens is that the ink, although delivered in a variety of ways, is always through a nib whose width is fixed. In order to produce a drawing with a variety of line thickness, several pens need to be used with a number of different width nibs. Tone is made by using various degrees of hatching and cross-hatching. Textures are achieved using a variety of imaginative marks.

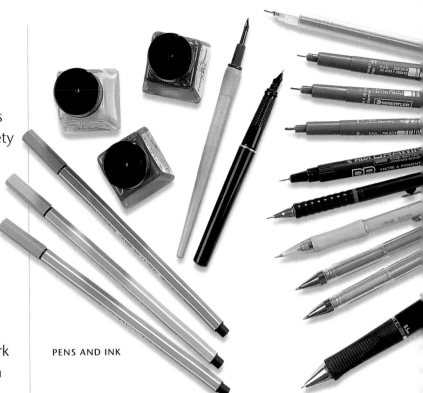

PENS AND INK

PAPER AND SUPPORTS  Certain papers work best with certain media so it pays to match the drawing implement to the support. There are three distinct paper surfaces: hot pressed (smooth), cold pressed, also known as NOT, meaning not hot pressed (a medium surface with a degree of texture) and rough (a pronounced pitted highly-textured surface). Smooth papers are best used for pen and ink drawings where the nib needs to move smoothly over the support surface. Smooth papers are less satisfactory when used with soft pigmented drawing tools like charcoal and chalk. This is because the pigment dust needs a textured surface to cling to. Most drawing papers are white but coloured papers are also available on which pastel pencils and coloured chalks work particularly well. The support surface is important as the correct choice can greatly enhance the quality of the drawing. Paper can be purchased in sketchbooks and pads or as loose, single sheets. Single sheets enable you to try out several different papers and can be cut or torn to size.

DRAWING BOARDS AND EASELS  Whilst paper bought in pads and sketchbooks has substantial card backing to keep it flat, loose sheets of paper are easier to work on if supported by a drawing board. Several sizes are available and you may find it a good idea to obtain a small board for working on location and a larger board for working on bigger drawings at home. Rather than use drawing pins to secure the paper to the board, invest in a couple of spring-loaded board clips. If using sketchbooks or paper secured to a board, it is not necessary to have an easel. However, if you find yourself working a lot in locations where it is difficult to find somewhere on which to rest a board, you may find it advantageous to invest in a portable sketching easel. There are many different models available but whichever you choose make sure it is easily transportable, easy to erect and above all stable.

# Techniques

This section of the book illustrates each of the drawing techniques used in the projects in a clear, straightforward manner. It explains how and when each technique might be used and also describes the tools used to achieve them. Techniques are an artist's visual vocabulary and can be practised in isolation without actually making a drawing. Familiarity with your materials and the effects they create enables you to concentrate and focus on the intended image. This section also offers a brief outline of basic picture-making fundamentals such as perspective and composition. There are also tips on how to select your subject and starting work.

LINE  Artists use line in order to encapsulate or capture a thing or an idea. This type of line is purely a graphic device and does not exist in reality. The line simply shows the edge of something, a position in space where one thing ends and another begins. However, the clever use of line can describe far more than just the shape of an object or person. The most adaptable and expressive drawing tools are those that allow the line being drawn to vary in thickness and/or tonal density. These include graphite, charcoal and pastel pencils. The ability to vary the quality of the line makes it possible for the artist to suggest both light, shade and texture. Several other drawing tools are less flexible due to the weight of the line being delivered having a fixed width. These include fine liners, and technical and ballpoint pens. When these types of drawing tool are used,

the artist needs to be particularly inventive in order to prevent the drawing from looking too mechanical and dull.

EXPLOITING THE SHAPE OF THE TOOL  Soft drawing tools like charcoal or Conté chalks are capable of producing a range of marks simply by altering the pressure applied as the marks are made. Altering the angle at which the tool comes into contact with the paper or even varying the speed at which the marks are delivered all create different effects. Beginners often forget to exploit this characteristic by holding the drawing implement in exactly the same way and applying the same degree of pressure for the entire drawing. This results in tired, dull drawings that lack sparkle. In order to exploit this characteristic, try to use not just the point of the drawing tool but any sharp or blunt edge it may have. Alter the pressure applied and turn the tool mid stroke or

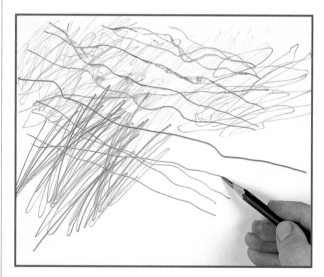

LINE

attack the paper using a stabbing action. Practise using the tool on a sheet of scrap paper first and try to obtain as many different marks as possible. Familiarizing yourself in this way with your chosen drawing implement will pay dividends.

TEXTURAL MARKS  Textural marks are used to describe the different surface characteristics of something. They are also used as a form of shorthand in order to suggest expanses of grass or the fluffy qualities of certain cloud formations. The making of textural marks is closely linked with using the shape of the drawing tool. By their very nature, soft, pigmented drawing tools that are capable of delivering wide areas of tone as well as line, make it easier to suggest a range of different textures than pen and ink or fine liners, both of which are essentially line tools. However, the qualities of an ink drawing can be extended by the clever use of diluted ink applied with brushes, sponges, bamboo pens or even fingers. As with all drawing, do not be afraid to experiment. This also applies to the

surface characteristics of the paper you choose to make the drawing on, as this can influence the quality of the finished drawing perhaps more than any other factor.

ERASING  Erasing should not be seen as only a means of correction. It can be used as a powerful tool in its own right for working back into areas of tone and line work. Textural effects can be achieved that would be difficult, if not impossible, by any other method. Use the eraser in much the same way as you would a drawing tool: laid flat, on its edge or cut into a point. Different erasers produce different marks, and because they are inexpensive you should obtain several different types to achieve the desired effect. Erasers, especially putty erasers, become dirty and clogged with pigment with use. This can lead to smearing rather than a pleasing clean mark. Counter this by cutting away the dirty part of the eraser with a sharp craft knife. Only use white or clear erasers as coloured erasers can often leave a mark, and take care not to tear or distress the paper's surface.

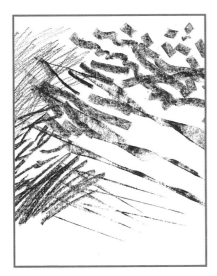

EXPLOITING THE SHAPE

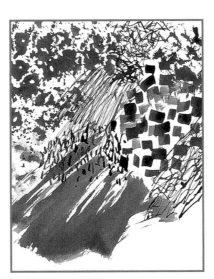

TEXTURAL MARKS

ERASING

TONE SCRIBBLING

TONE CROSS-HATCHING

TONE BLENDING

**TONE** Tone is used to describe the quality and degree of the light falling on the subject along with its intrinsic colour. A range of tones helps to describe form – without tone things appear flat. The application of tone is sometimes known as shading and it can be done in a variety of ways depending on the type of drawing tool being used. When using graphite, charcoal or pastel pencils, tone can be scribbled onto the drawing. Varying the density of the marks and the pressure used to make them result in the tone rendered being either darker or lighter.

**Scribbled tone** When applying scribbled tone, constantly alter the direction of the marks so that they do not build up all running in the same direction as this tends to lead the eye. When applying dark tone, hold the drawing implement near to its point to allow for extra control; when applying lighter tones that require a lighter pressure, hold the implement higher up the shaft.

**Hatching** is a way of applying and building up areas of tone using a series of parallel lines. Essentially, it is a linear technique that is especially effective when rendered with pen and ink, technical pens or fine liners that deliver a line of constant width. The density of tone is achieved by altering the distance between the hatched lines. The closer together the lines are rendered, the darker the apparent density of tone.

**Cross-hatching** uses the same technique but blocks of lines are drawn crossing each other at an angle. The technique is relatively slow but it is possible to build very subtle tonal gradations using this method.

**Tone blending** Soft drawing materials can be blended and manipulated by smudging with the finger, paper towel, a torchon or paper stump. Done to excess, the technique can look overdone leading to a drawing that looks soft and lacks focus. Take care to wash your hands before blending with the finger as grease can spoil the effect.

**Stippled tone** can be made with all drawing materials. The tone is built by varying both the size and the density of the marks. A combination of dots, dashes and ticks is made by tapping the drawing tool onto the paper. Used with pen and ink and even pencil, the technique can be slow. With charcoal or Conté, however, the build up of tone is fairly rapid. The technique can be used by itself but is often better used combined with other techniques.

TONE STIPPLING

TONE WASH

MASKING

WASH TECHNIQUES can be used with all drawing media, many of which are conveniently available in water-soluble variations. Colours and tone can also be added by using ink or watercolour thinned with water. The more water added to the mix, the lighter the colour or tone will be. The washes can be applied 'wet over dry' by allowing each wash to dry before applying the next or worked 'wet into wet', by applying a wash over a wet wash.

MASKING Usually associated with painting, masking techniques can be extremely useful and successful when used with dry drawing media. When used in drawing, the technique enables distinct edge qualities to be given to areas of tone or texture. Scribbling tone up to a complex edge or even a straight line takes time and can look awkward. Using a mask of torn or cut paper or card leaves a crisp, well-defined edge. The mask needs to be carefully held in place as the drawing tool is scribbled over both the mask and the paper. If the mask slips whilst the tone is being applied the effect will be spoilt. Straight edges can just as easily be achieved by scribbling up to a ruler.

FROTTAGE This technique requires the drawing implement to be rubbed over the paper's surface which in turn has been placed over a firm textured surface such as a rough plank of wood, the side of a brick or a sheet of corrugated cardboard. The texture of the object is transferred to the drawing in much the same way as one does a brass rubbing. The technique requires a surface with a relatively pronounced texture, together with a sheet of paper that is thin enough for the texture to read through. Interesting textural combinations can be built up with a unique quality that is quite different from those marks made directly with the drawing tool.

FROTTAGE

## Composition

The organisation of the space and the elements within the picture area is known as composition. This arrangement of pictorial elements can achieve several things but primarily its objective is to achieve a balance and visual harmony within the picture area and to hold the viewer's attention by leading and directing the eye to specific areas of importance. All the elements included within the picture have an effect on the composition. Positive and negative shapes, colour, tone, size, perspective, form and texture all require equal consideration. Several formulae have been devised over the years that divide the picture area into an invisible grid upon which important elements should be positioned. Perhaps the most well-known formula is based on the 'golden section' devised by the mathematician of antiquity, Euclid. If the theory is followed, elements arranged according to the golden section appear to be in the most pleasing position within any given picture area. The theory states that an area can be divided in such a way so that the 'smaller part is to the larger as the larger part is to the whole'.

A simpler formula than the golden section but one that in use is not so very different, is the 'rule of thirds'. This simply divides the picture area into thirds by using a grid of horizontal and vertical lines. Important elements are positioned on or about these lines or at the points that they intersect resulting in a pleasing and well-balanced image. The shape or format the drawing takes should also be given consideration as this plays an important part in the composition: will the image be square,

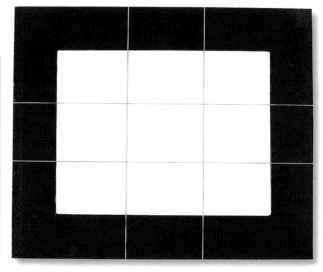

COMPOSITION AID

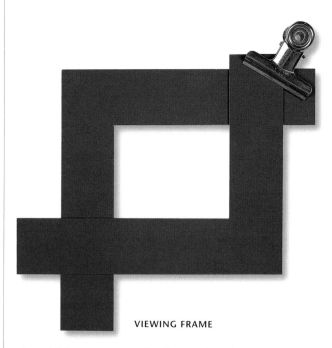

VIEWING FRAME

should it range vertically or should it spread lengthways horizontally?

Two simple devices can be made that not only help with composition but also act as viewfinders to help decide on format. In order to make the first, cut a rectangle out of a sheet of card and stretch two elastic bands horizontally and two vertically across the opening to form the grid dividing the opening into thirds. The second is made by cutting out two 'L' shapes from a sheet of card. These are used to make a frame that can be secured at the corner by a clip. These

L-shaped frames can then be looked through and adjusted until the desired format is achieved. Making one side of the frames white and the other black helps when used to view either light or dark subjects as the light side isolates dark subjects well, whilst the black side has the opposite effect and isolates light subjects.

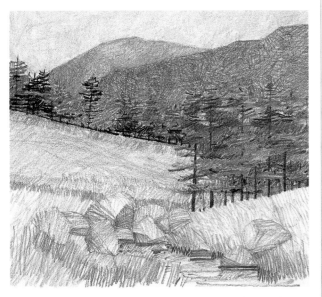

**AERIAL PERSPECTIVE** Sense of recession achieved by colour and tone

# Perspective

There are two types of perspective: linear and aerial. Linear perspective is a system that was devised during the Italian Renaissance in order that an image of three-dimensional reality could be convincingly depicted on a two-dimensional flat surface. The rules of perspective dictate that all parallel lines on any flat surface or plane (other than a surface viewed straight on) if extended eventually meet at an imaginary point in space known as the 'vanishing point'. This point is on the horizon line that runs horizontally at eye level across the field of view. All parallel lines that originate below the eye level run up to meet the vanishing point and all parallel lines that originate above the eye level run down to meet the vanishing point.

Aerial perspective is also known as atmospheric perspective and its use is particularly useful when drawing landscapes. As a general rule, colour and tone become lighter the further away they are from the onlooker. Colours also become cooler with a distinct blue bias. Objects in the distance tend to lack definition and detail because they appear smaller in size.

**LINEAR PERSPECTIVE** Sense of recession achieved by changes in scale.

## Finding your subject and getting started

Deciding on a subject is perhaps the first obstacle you will need to overcome. Suitable subjects are not always glaringly obvious, then again suitable subjects surround us everywhere. Perhaps a leaf should be taken out of the American artist John Singer Sargent's book who would apparently trek diligently to find his desired subject then turn his back on it and paint what was immediately behind him. A landscape does not need to be grand and expansive, intimate corners are interesting too and often more practical to draw, being less exposed. Whatever and wherever your subject is, do not be seduced into starting work immediately. Take time to look about you – it may well be that the most interesting view is behind you!

Always begin work by taking the time to make a few thumbnail sketches. These are small drawings that serve a number of purposes. They enable you to decide on the composition, what is to be included and what is to be left out. The first attempt may not be the best so making several enables you to explore a few possibilities visually. This process also helps you decide on the best format for the drawing. Just because your sketchbook page or sheet of paper is a rectangle of a specific size does not mean your drawing has to be the same size and shape. Finally, making thumbnails using the same materials that you plan to work with enables you to 'loosen' up. Think of it as doing a few stretching exercises before committing to a five mile run!

THUMBNAIL SKETCHES

## Working on location

Making a drawing requires remarkably few materials and most drawing materials are compact and light, which makes working on location a relatively easy exercise. There are two distinct types of drawing. The first are sketches, simple, straightforward works that are economical in size and have usually been made using a single drawing material. The second type of drawing is larger, often involves using several materials and is more involved and complex. It is often drawings or sketches of the first sort that are made on location in order to make drawings of the second sort back in the studio.

A basic drawing or sketching kit need only include a soft graphite pencil or stick, an eraser and a small pocket-size sketchbook. The combination of graphite and eraser enables a wide range of marks and effects to be achieved with the minimum of equipment. An alternative to the pencil and eraser might be a fine liner or sketching pen. However, both of these are essentially linear tools, so the drawings you make would tend to be line drawings and although tone

ON LOCATION DRAWING KIT

and texture can be described, the process takes longer than when using a softer pigmented drawing tool.

However, more involved work can and should be made on location. Dress sensibly: even on relatively warm days it is easy to get cold standing or sitting still, and layers of clothes can always be removed. Working standing up can be awkward unless your support or drawing surface is resting on a convenient fence, tree trunk or rock, so a small folding stool or chair is invaluable. Take whatever materials you think you will need. If working on a sketchbook or drawing pad, choose one with a substantial card backing as this acts as a good support. If you are working on sheets of paper you will need a suitably-sized drawing board. Small bulldog clips will secure the paper to the board or hold a sketchbook page open against the inevitable wind.

An invaluable aid to your work is a camera, which although no substitute to working on location, is invaluable for making back-up images and to provide material that can work as an aide-memoire for further work.

SKETCHBOOK AND FINE LINER

## Demonstration 1

# Fields and trees
## *Graphite pencil*

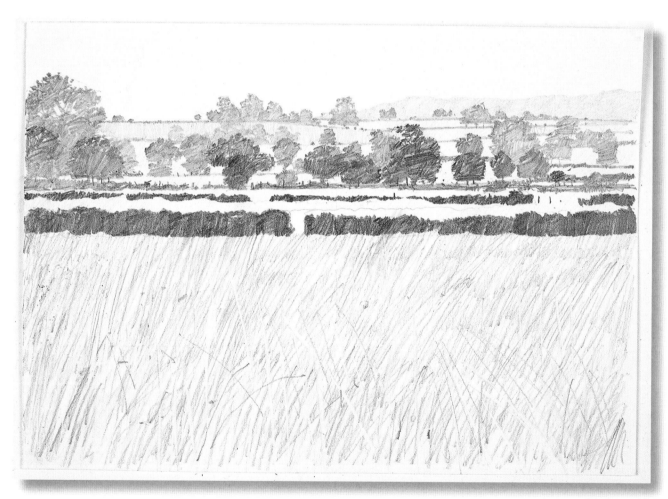

Being able to convincingly depict the illusion of space in landscape drawing is very important – without it your drawings will simply look flat. Elements of the landscape will look as if they exist next to each other rather than in the foreground or in the background. Fortunately, artists employ the device of perspective, which, if used properly ensures that the illusion of three dimensions on what is a two-dimensional image is convincingly depicted.

The form of perspective of most interest to the landscape artist is aerial or atmospheric perspective. The rules of aerial perspective are simple. Firstly, colours look cooler and more blue the further away they

are from you. This is due to dust and atmospheric haze. Tones are generally lighter and colours more subdued, and both detail and textures are less in evidence as objects appear smaller and less distinct when viewed in the distance. When using simple monochromatic drawing materials like graphite pencils or charcoal, tone becomes especially important. Although you are not using colour, you must remember that all colours have a tonal equivalent, something that is plainly evident when looking at a black and white photograph. In order to make a successful drawing, learning how

to make and use these various degrees of tone is essential; it will also help when you come to consider working in colour as tone also helps convey both mood and atmosphere.

The graphite pencil is the most familiar of all the tools used in drawing. It is without doubt the easiest and most adaptable to use, and by using a suitable grade, a full range of tone from white to full black can easily be achieved. This project shows how organizing a series of simple tones and adding a few textural marks can create a landscape that is both spatially convincing and quick to make.

## Subject

This view across farmland exhibits all the characteristics and rules associated with aerial perspective. Take special note of how the colour in the distance appears cooler and the tones generally lighter, uniform and lacking in contrast.

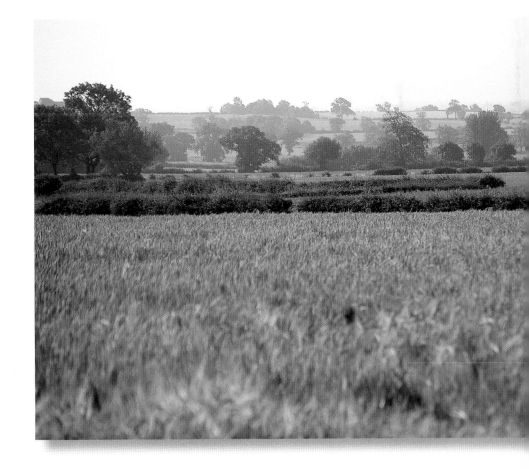

## Materials

*Sheet of white cartridge
(drawing) paper
420 x 297 mm (16¹/₂ x 11³/₄ in)*

*4B graphite pencil*

*Hard eraser*

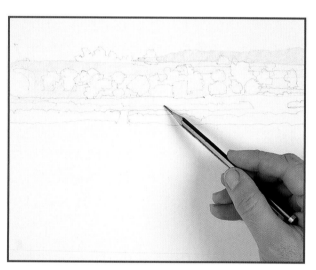

1 Use the pencil to lightly sketch in the position of the trees and the hedgerows running horizontally across the image. In this composition, the sky is a flat, pale blue and not of much interest. To counter this, more is made of the foreground. Had the sky been more interesting, the horizon would have been positioned low to make it into more of a feature.

2 Apply a light tone to the distant hill and to the far fields. Apply the tone using multi-directional strokes. Holding the pencil high up the shaft will help you scribble the tone on lightly.

### Artist's tip
When making a tonal drawing, keep any outline sketch very light so that the line disappears when the tone is scribbled over it.

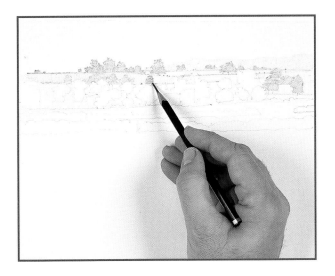

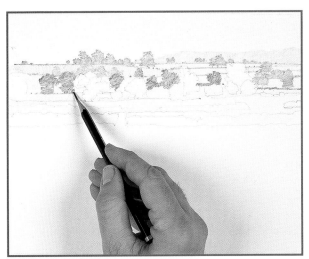

3 Draw in the distant trees along the horizon using a slightly darker tone. Hold the pencil nearer the point to enable you to exert more pressure and exercise greater control. Take care as you scribble on the tone and make sure you leave small gaps in the foliage where the sky and distant hills will show through.

4 Move on to the trees across the middle distance. Add a little more pressure and darken the tone slightly. As before, take note of the shape of each tree and scribble on the tone carefully until the shape is right.

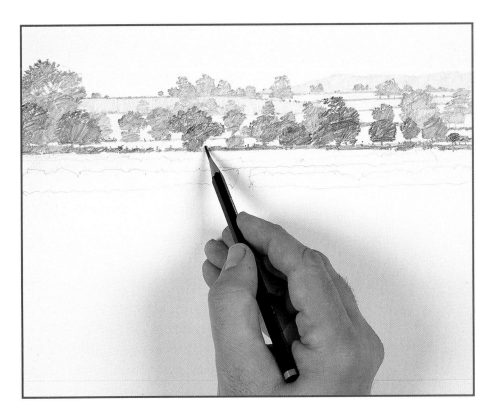

5 Draw in the closest trees by applying still more pressure. Scribble on the tone in a number of different directions adopting the same technique used to draw the hedgerows. Add a few lines, dots and dashes into the hedgerow to represent the odd fence post or branch.

6 Scribble on a dark tone to represent the two hedgerows that run horizontally across the centre of image. To obtain a different quality, use a piece of thick paper as a mask. Tear one edge so that although straight it is slightly uneven, and scribble the tone up to this edge. The unevenness will help to achieve a more natural result. When the paper is removed, the top of the hedgerow will have a distinctly different feel and quality to the bottom of the hedgerow.

**Artist's tip**
Dirty erasers will smudge the work. To avoid this, cut your erasers into segments and discard them once they are dirty.

7 Scribble in directional strokes into the foreground to represent the cereal crop. Make the pencil marks larger in the foreground (at the bottom of the page) and smaller in the distance (just below the hedgerow). Once you have done this, work into the area using the sharp edge of a cut piece of a hard eraser to achieve a crisp, sharp line. Finally rework the area with pencil and repeat the process with the eraser until you are satisfied you have achieved a layered effect as seen when looking through grass.

# TRY A DIFFERENT ...

### ... MEDIUM

Charcoal is used for this image, which is similar to the main project in that it requires a series of different tones to be organized in such a way that they suggest depth. However, due to the effects of aerial perpective in the scene, dark tones sometimes appear behind lighter tones (circled below). An added sense of depth is achieved by the linear perspective of the row of fence posts receding down the hill into the middle distance.

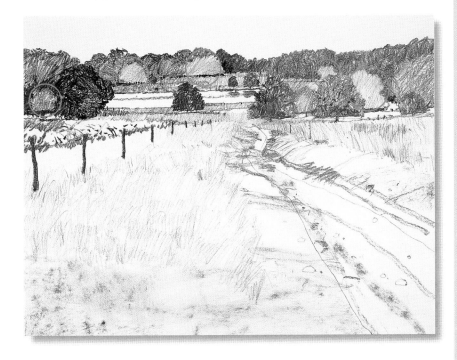

### ... VIEW

Here, the early morning mist helps simplify the view across a valley to a distant Tuscan hill town. Four tones, each one lighter than the next, are all that is needed to draw in the hills, while the fence posts in the foreground can be drawn in sharp focus together with the grass and other foliage.

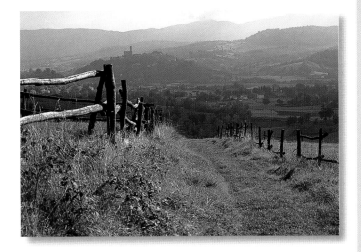

## Demonstration 2

# Mountains and cliffs
## Coloured pencils

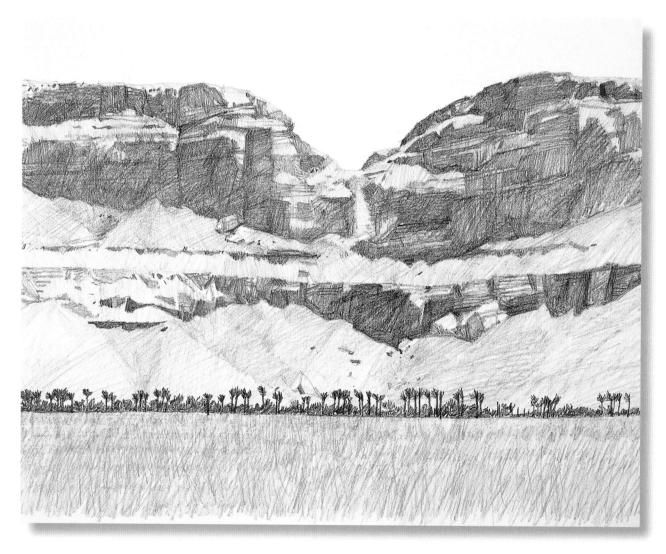

Mountains, cliffs and rock faces all make good subjects to draw. Two difficulties seem to regularly arise. The first is how to make them appear as steep or as high as they are in reality, and the second is what techniques to use to draw the cracks and various strata that often make up the rock face. Using an upright format can solve the first hurdle as the eye tends to travel vertically rather than horizontally. Alternatively, clues to the height

of the subject can be provided by including a reference in the image so that a comparison can be made. This could be a building, a person or, as used here, trees. The viewer simply uses the height of the palm trees, which are known to be tall, to assess the height of the cliffs.

The actual appearance of any subject is affected and altered by the quality and direction of light falling on it. This is especially true of mountains and rock faces. Seen at different times of day and in different lighting conditions, the same rock face can look completely different. Lit from the front and above so that few shadows are cast, the rock face appears flat and featureless. Lit from the side, however, the light hits some parts whilst throwing others into deep shadow. This makes the rock face come

alive as texture, strata and each tiny change of angle becomes increasingly evident.

The more interesting the subject, the easier it is to draw as there is greater opportunity to use many of the textural techniques at your disposal to help describe it. As the sun moves, the appearance of the rock face will quickly change, so if you are working on location you will need to work fast. Start by drawing and establish the main blocks of tone before turning your attentions to any detail. Working with what might be described as a fast medium such as charcoal, chalk or graphite can also help, as can erasing techniques. These allow you to work back into areas of tone, creating details and textures that might take longer to achieve if using pigmented mark-making tools.

## Subject

This bank of cliffs is part of the long escarpment that towers high above the river Nile. The row of palm trees along its base provides a clue to the height of the cliffs. The subject is practically monochromatic and could be drawn in a single colour, however, interest is added by working with four colours (listed overleaf) that are traditionally used in many classical drawings.

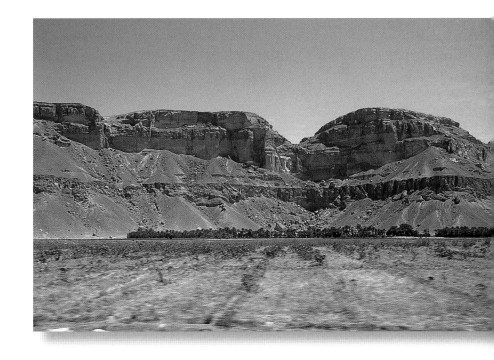

## Materials

*Sheet of white hot pressed drawing paper 420 x 297 mm (16$\frac{1}{2}$ x 11$\frac{3}{4}$ in)*

*Drawing pencils in terracotta, chocolate brown, ochre and black*

1 Using the terracotta pencil, lightly sketch in the position of the cliffs. Draw in the various rock faces and the position of the shadows. The drawing need not include a great deal of detail at this early stage as it is only meant as a guide for subsequent work.

### Artist's tip
Keep the point of your pencils sharp for longer by periodically turning them between the fingers as you work.

2 Use the chocolate brown pencil to scribble in a tone that represents areas that are deep in shadow. Use enough pressure to give a deep tone, but remember that these areas can and will be worked over again later. Where the rock faces change direction, echo this by changing the direction of the pencil marks.

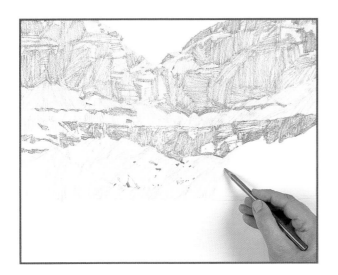

3 Use the ochre pencil to scribble in a lighter tone over areas in the light. As before, use directional strokes that echo the direction of what you are drawing. You will find that it is easier to apply a light tone if you hold the pencil higher up the shaft as this prevents the application of too much pressure. For darker marks hold the pencil nearer the point.

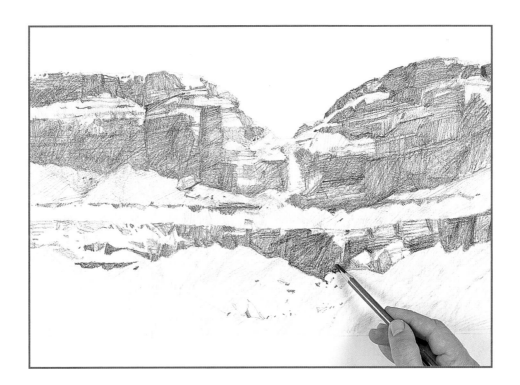

### Artist's tip
When working on tonal drawings, build up the tonal areas carefully. Remember that it is far easier to add or darken the tone than it is to remove or lighten it.

4 Use chocolate brown over the ochre to darken it in places. The effect is subtle and the brown is applied very lightly. Use the same brown in the shaded areas to make a series of linear marks that run horizontally across the rock face. Work some black over the areas in deep shade, using directional strokes that follow the contours of the rock.

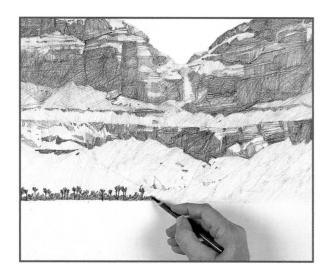

5 Use black pencil to draw in the line of palm trees and foliage at the foot of the cliff face. Ensure that the point of the pencil is sharp so that the palms can be drawn precisely and appear to be in sharp focus. Notice how the palm fronds tend to bend over to one side as if buffeted by the prevailing wind.

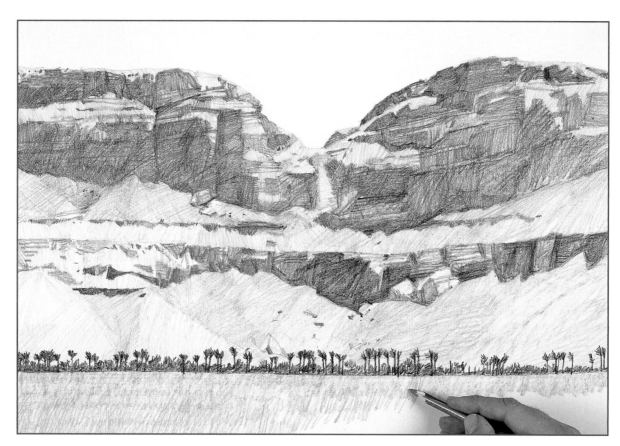

6 Finally, return to the terracotta pencil used to sketch the cliffs in step one. Use it to add tone and colour to the lower slopes where rocks and debris have fallen from and built up against the main rock face. Use the same pencil to scribble in the grass across the foreground. Use larger slightly heavier strokes here to help give a suggestion of perspective.

# TRY A DIFFERENT ...

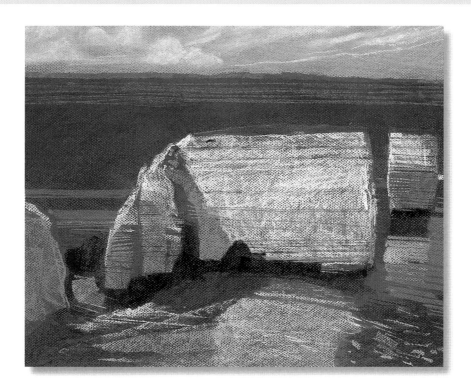

### ... MEDIUM

This drawing is made using hard chalks or pastels on a dark grey textured paper. This combination results in a drawing which, although simple, looks almost photographic. The colour of the paper works to intensify the limited colour palette, while the paper's coarse grain does all the work by recreating the texture of the rocky outcrops.

### ... VIEW

The process to draw this seemingly complex image is no different from that used in this project. Try breaking the image into three distinct tones: light, medium and dark. Once applied, the image will become apparent and you can work back into it drawing in detail and extending the tonal range.

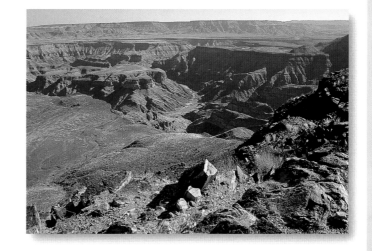

## Demonstration 3

# Distant peaks
*Pastel pencils and hard chalks*

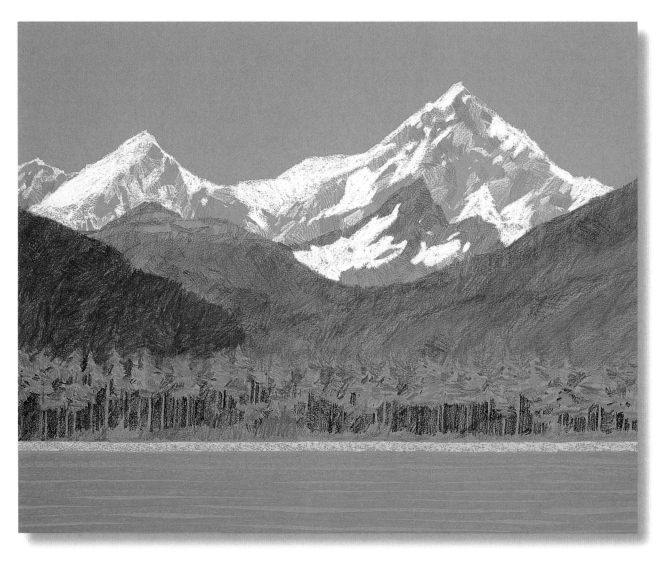

Colour plays an important part in the landscape. It not only helps describe the appearance of things but perhaps more importantly creates mood, helps describes weather conditions and is important in creating the illusion of space and the all-important aerial perspective. However, colour needs to be used with care. Much can be achieved using a limited palette of colours and in reality the colours present within a

particular landscape can be deceptively simple. Indeed the use of too much colour can result in a drawing appearing as an incomprehensible muddle.

This approach is helpful as the choice of colours available when using pastel pencils and chalks whilst comprehensive is by no means limitless and their use does require a degree of what is commonly referred to as optical mixing. Unlike paint or coloured inks, which are invariably mixed on the palette, drawing materials consisting of dry pigment, such as coloured pencils or pastels, are mixed on the support. This happens by physically blending the colours together using a finger, rag or paper stump, by applying the pigment in layers so that one

layer reads through another, or by applying different pure colours using a series of very small marks that, due to their proximity to one another seem to mix together. In reality all of these ways of applying the pigment are often used in tandem.

The important thing with any drawing, regardless of the medium, is to try to achieve and maintain a fresh directness of application. Nothing makes a drawing appear more pedestrian than woolly, laboured mark making. In order to achieve this you need to practise with your chosen material to understand its full potential, and you also need to have some kind of plan as to the order in which you intend to execute the proposed work.

## Subject

These distant snow-capped peaks that can be seen towering over ancient pine forests provide the ideal opportunity to use aerial perspective. The range of colours used is simple but sufficient to represent the scene perfectly.

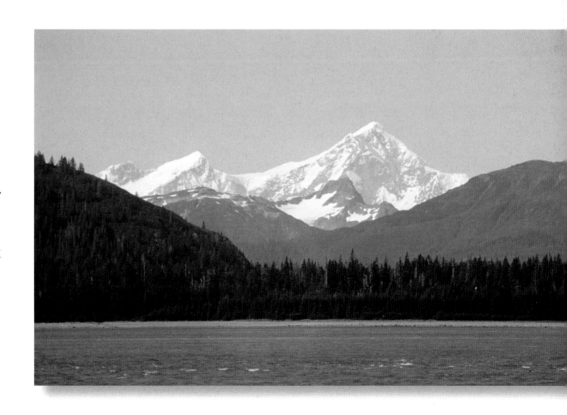

## Materials

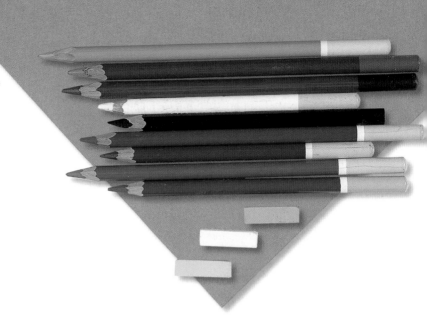

*Sheet of light blue pastel paper
380 x 545 mm (15 x 21¹/₂ in)*

*Pastel pencils in ultramarine
blue, Prussian blue, white,
black, sap green, dark green,
raw umber, dark ochre and
yellow ochre*

*Hard chalks in light blue,
white and yellow ochre*

*Fixative*

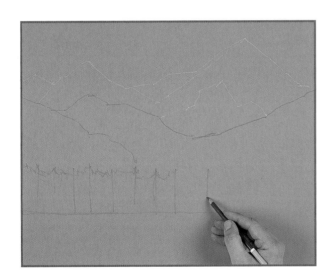

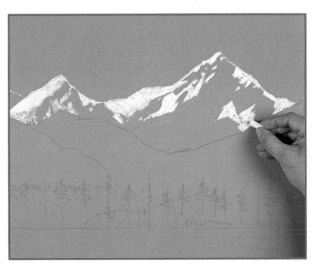

**1** Working on a mid toned blue pastel
paper helps maintain a sense of colour
harmony and adds a feeling of solidity to the
work. Begin by sketching in the composition
by using colours that are in keeping with the
relative areas. White for the snow-covered
peaks, blue for the lower mountains, dark
green for the trees and ochre for the strand
of sand.

**2** Once the composition has been
established, return to the snow-covered
peaks and establish the snow covered areas
using the white hard chalk, paying careful
attention to how the snow collects on
certain areas only.

3 The white pastel pencil is then used to draw in the areas of snow that are in shadow or perhaps less deep. Use hatched and cross hatched strokes that follow the contours of the mountain.

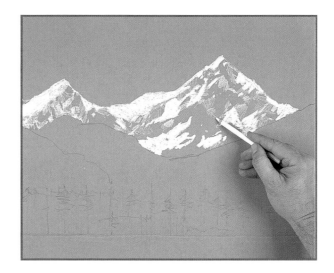

4 Most of the deeper shadows on the snow-covered mountain are suggested by using the colour of the paper support. Use the ultramarine blue to hatch in the deeper shadows on the mountain side and to add a mid toned blue colour across the lower mountains that run across the centre of the image. The darker passages are suggested by hatching in areas of raw umber.

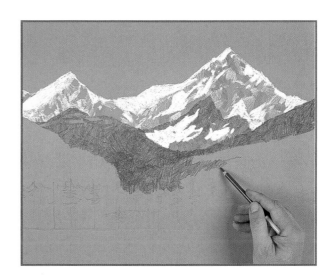

5 Consolidate this strip of high ground by working into it using the raw umber pencil. Then use the same umber pencil to darken the outcrop of high ground on the left-hand side of the image.

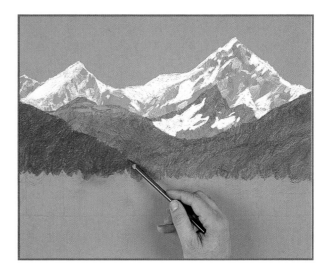

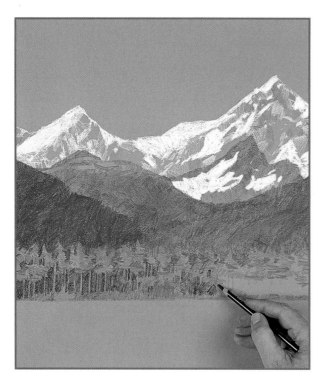

6 With the mountains established, begin to draw in the tree line. Draw in the tree trunks using the dark ochre before drawing in the light greens using sap green and the greens that are in shadow using the dark green. The dark areas deep within and between the trees is then scribbled in using the black.

7 Draw the strip of sand using a simple line of the yellow ochre chalk. This is followed by the sea which is drawn in using a series of roughly parallel marks using the light blue chalk. The lines add perspective to the foreground and suggest the slight swell that can be seen on the otherwise calm water.

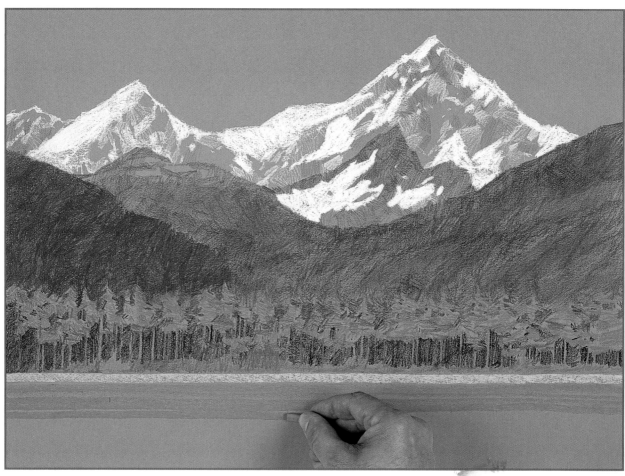

# TRY A DIFFERENT ...

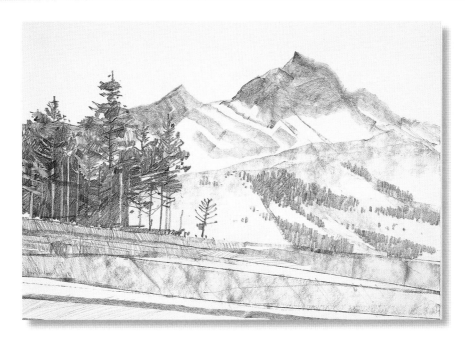

## ... MEDIUM

Soft graphite is used to draw a similar scene. Flat graphite blocks were used to draw in the rock strata seen in the foreground and the distant mountain. A 9B graphite stick was then used to sketch in the trees and to suggest the distant trees that cloak the lower slopes of the mountain.

## ... VIEW

The view of peaks has been given added interest by throwing a rock into the water. The expanding ripples break up the mirror-like reflection of the peaks and add a sense of movement to the scene.

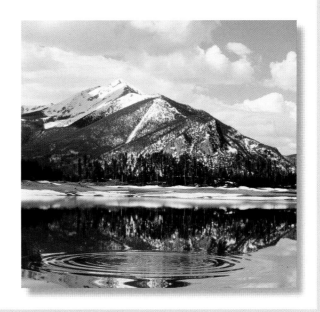

# Demonstration 4

# **Skies** *Charcoal pencils*

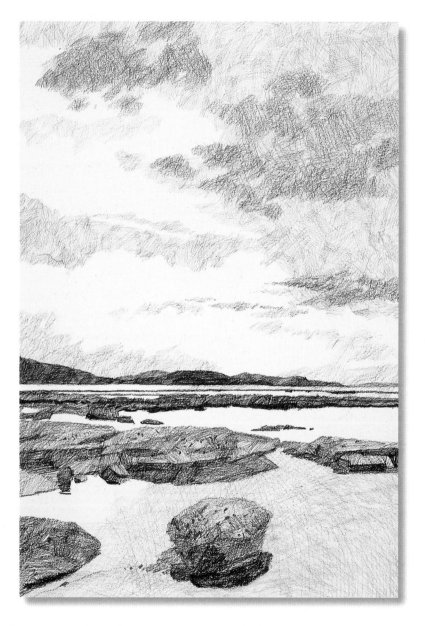

Most landscape drawings unless they are intimate detailed studies will include a glimpse of the sky. Often because the focus is on the topography or because it is clear and blue the sky area is simply left as a blank space. Skies however are important even when not seen as they are the source of light and when featured play an all important part

in suggesting space, mood and atmosphere. Skies also give important clues as to the prevailing weather conditions or even season or time of year. It is important when drawing the sky to link it to the landscape, it should be an integral part of the whole image. It should also match the lighting conditions seen in the rest of the landscape but unless intended should not dominate or overpower. In order to give an impression of depth the correct use of aerial perspective is especially important when drawing skies. If you look carefully you will see that even clear blue skies have perspective, this is immediately

noticeable in the way that the colour becomes lighter in tone the nearer it gets to the horizon. This sense of recession is even more noticeable in cloudy skies. Cloud shapes tend to overlap with the clouds immediately overhead positioned in front of clouds that are further away and so lower in the sky. Clouds overhead are also invariably larger and have more mass. Clouds also have distinct form having a top, bottom and sides. This is most noticeable when they are illuminated by bright sunlight but less noticeable in dark overcast skies or on grey nondescript days. Skies offer the perfect opportunity to exercise a degree of licence, this is achieved by editing out or even adding clouds to clear skies in order to improve the composition. Perhaps the only rules to follow are to avoid any symmetrical arrangements and, as previously mentioned, to match the lighting conditions to those evident in the landscape.

## Subject

Our subject is a typical good weather sky. Without the clouds the sky would be a clear blue, beautiful, but from an artist's point of view lacking in interest. Without the clouds the composition would need to be changed. By making the sky part of the composition it becomes possible to utilise an upright format rather than the traditional landscape format which exaggerates and draws attention to the horizontal elements.

## Materials

*Soft, medium and
hard charcoal pencils*

*Sheet of white Not
surface drawing paper
420 x 297 mm (16$^1$/$_2$ x 11$^3$/$_4$ in)*

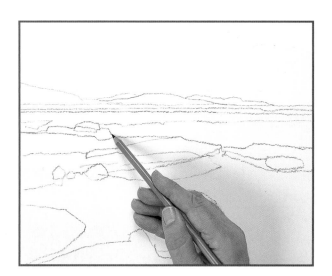

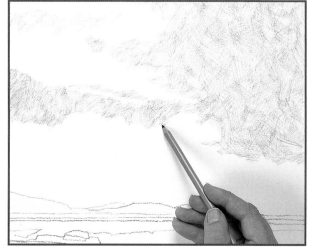

1 The basic shape and position of the rocks
seen in the foreground together with the
coastline spreading horizontally across the
centre of the image are sketched in using the
soft charcoal pencil. You can also if you wish
indicate the position and shape of the main
cloud masses but use very light almost
imperceptible marks.

2 Rather than using heavy applications of
charcoal dust which is then blended and
distributed over the support surface with
finger, torchon or rag the charcoal pencils
are used to build up the tone gradually using
loose hatching and cross hatching. Charcoal
pencils tend to be harder than stick charcoal
and slightly more controllable. Use the
medium pencil and light hatched strokes
to build up the tone of the blue sky. The
shape of the clouds are formed by the
white support.

### Artist's tip
Holding the pencil high up the wooden
shaft encourages you to apply a light
pressure which will result in lighter marks.

**3** The soft charcoal pencil is then used to apply dark tones across the distant landmass, this tone is lightened slightly towards the right hand side of the image. The same pencil is used to apply a dark tone to the far rocks that have been exposed by the low tide. Tone is then applied to the rocks across the foreground. This time the hard pencil is used which creates a crisper line.

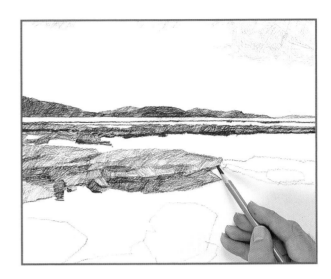

**4** Darken beneath each of the rocks and apply a dark tone to each reflection. Use a series of more precise marks to suggest the pitted and eroded surface of the rocks that are in the foreground.

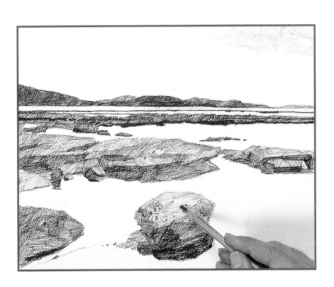

**Artist's tip**
It is easier to sharpen soft drawing materials by using a sharp craft knife rather than a pencil sharpener.

**5** The medium charcoal pencil is then used to loosely scribble on a mid tone to the area of water where the deep blue sky can be seen reflected, varying the direction of the strokes. When scribbling or applying a light tone hold the pencil high up the shaft as this makes applying pressure more difficult and results in lighter marks.

6 Use the same technique to apply the darker tones in the clouds and the sky. Work methodically paying attention to the shapes you are drawing. When you are applying tone remember that it is easier to darken a tone than it is to lighten it.

> **Artist's tip**
> As areas of tone are applied and built up, avoid smudging the work by resting the hand on a piece of paper or paper towel.

7 The image is almost complete and the drawing has an almost luminous quality as the light is reflected back off the sea between the dark rocks and distant landmass. This effect is enhanced by applying more dark detail to the rocks in the foreground. Once finished fix the image to prevent any smudging which might spoil the effect.

# TRY A DIFFERENT ...

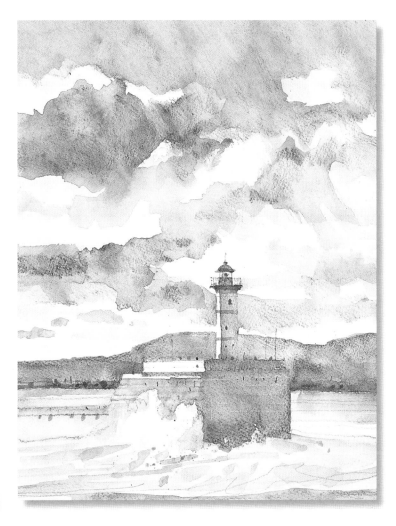

### ... MEDIUM

Occasionally, circumstances require you to work at speed, and dark pigmented materials like charcoal and graphite are ideal in these circumstances. A recently new development is water soluble graphite sticks. These enable you to make a rapid on the spot sketch, as we have done here. Later the drawing can be worked into using water to develop tones and elaborate what was a very simple basic sketch that took only minutes to make.

### ... VIEW

The sun rising into a stormy morning sky over this urban landscape makes for a dramatic image. Try using stick charcoal and white chalk or if you are in an adventurous mood why not dip pen and wash.

## Demonstration 5

# Winter landscape
*Charcoal and chalk*

Drawings made on mid-toned paper using black and white drawing materials have a completely different character to drawings made on white paper. Working on white paper often means that a great deal of time is spent building up dense, dark tones – a process that is considerably easier on a toned background. A dark, pigmented tool is used to describe the image, using tones that become gradually darker as the drawing progresses. Toned paper, however, has the added advantage of supporting white pigment, a material that is almost redundant when drawing on a white background. This means that the tones can be pushed in both directions: darker by adding black and lighter by adding white. This technique can make balancing tones easier for the beginner.

If you do not have a sheet of toned paper, it is easy to prepare your own. Using a rag, simply rub charcoal or graphite powder evenly into the surface of a sheet of white paper until the desired tone is achieved then apply a coat of fixative. Use a paper that has sufficient tooth or surface texture to hold the pigment.

When making drawings using soft pigmented drawing materials like charcoal or chalk, you will find that plenty of pigment dust is generated as the drawing tools move across the abrasive surface of the paper so the image will require to be fixed at regular intervals. If you do not apply fixative, the pigment dust builds up to such an extent

that it cannot cling to the paper. It stays loose and is simply moved around, eventually falling or blowing away. Fixing will allow more charcoal or chalk to be built up in layers. This is a relatively fast technique that allows large drawings to be made quickly, an especially important factor if working outdoors in conditions similar to those seen in this project. The technique also benefits the subject matter of this project, in that although predominantly white, it has distinct patches of darker tone where the uneven surface of the landscape shows through. This is represented by the texture of the toned paper showing through the white chalk.

## Subject

The bright sunlight reflecting off the white, snow-covered fields throws the darker hedgerows and trees into dark silhouette creating a strong patchwork design. The view can be drawn using a limited tonal range, but notice how the fields are anything but plain, flat white. Also notice how the sky is darker in tone than either the clouds or the fields.

## Materials

*Mid-grey sheet of pastel paper*
*380 x 545 mm (15 x 21¹/₂ in)*

*Hard charcoal pencil*

*Thick stick of soft charcoal*

*Eraser*

*Fixative*

*Stick of white chalk*

*White pastel pencil*

---

1 Using the hard charcoal pencil, carefully sketch out the position of the hedges, fences, buildings and trees. Notice how only a central portion of the view has been drawn. Do not be afraid to use a certain amount of artistic licence by visually editing the scene, removing or adding elements if it suits or contributes to the composition.

2 When all the elements are in place, continue to use the hard charcoal pencil to block in the hedges and trees. Use directional open marks to suggest the linear pattern of branches and apply increased pressure to make the darker marks where the foliage is dense on the evergreen conifers.

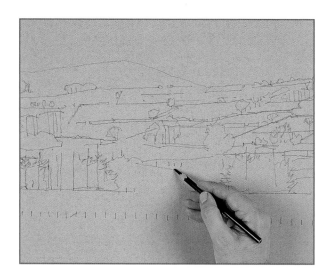

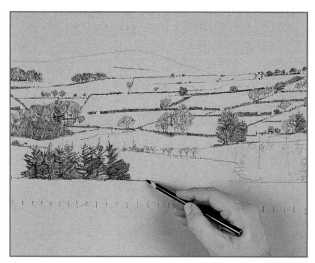

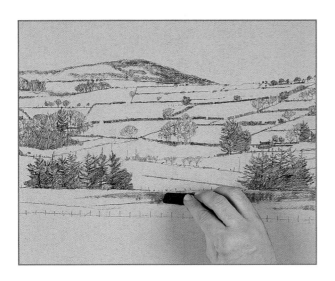

3 Use the thick stick of soft charcoal to block in a tone across the distant hillside and across the field at the bottom of the slope. Use the side of the stick to make the marks across the field by placing the stick flat onto the paper and dragging its entire length across the area to be drawn.

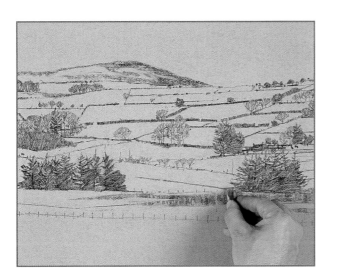

4 Use the sharp edge of an eraser to work into both these areas. Vertical strokes suggest dried reeds and grasses that poke high above the layer of snow. Give the drawing a light spray of fixative at this point to prevent the work from smudging.

### Artist's tip
When using stick charcoal you can keep your fingers clean by wrapping a piece of silver foil around the part of the stick being held.

5 Using the stick of white chalk, draw in the clouds. Use the side of the chalk, turning it as you draw to make the billowing white shapes. Use your finger to gently push the pigment into the paper but try not to overdo this. Keep the marks direct and fresh. Pull out a few wispy clouds by pulling the chalk lengthways across the paper.

6 Use the white pastel pencil to scribble white across the fields. Work around the trees and hedges, carefully breaking up and avoiding any hard edges by drawing into the linear pattern of twigs and branches. As before, maintain a point on the pencil by constantly turning it as you work.

7 Block in larger expanses of white using the white chalk. Try not to over-blend the chalk with your fingers to avoid a heavy, dense application. The grey paper needs to show through in places to represent the undulations of the landscape and the patches of vegetation pushing through the carpet of snow. Once complete, fix again with a light spray of fixative.

8 Use the hard charcoal pencil to scribble in the longer grass in the foreground and to darken some of the trees. Rather than scribbling over the area indiscriminately, use directional strokes to suggest the actual shape of the trees even though some of this work might be lost in the darkest passages.

# TRY A DIFFERENT ...

### ... MEDIUM

Whilst on first sight very similar, this alternative drawing is executed in a completely different way. The white paper represents the snow and needs to be treated with as much consideration as the positive marks made with the pen. Diluting the ink with a little water makes it possible to create a mid tone that is used to depict shadow and to suggest a little textural relief in the large white expanses that are the fields.

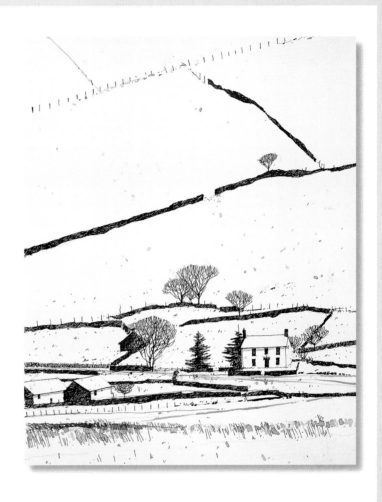

### ... VIEW

The deep blue shadows suggest the use of a blue support that can simply be left showing in those areas. An eraser can be used after the application of white chalk to 'draw' in the numerous tracks in the snow made by the sheep.

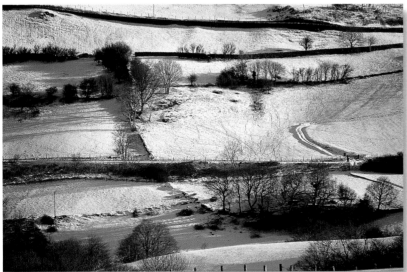

## Demonstration 6

# Waterfall *Conté*

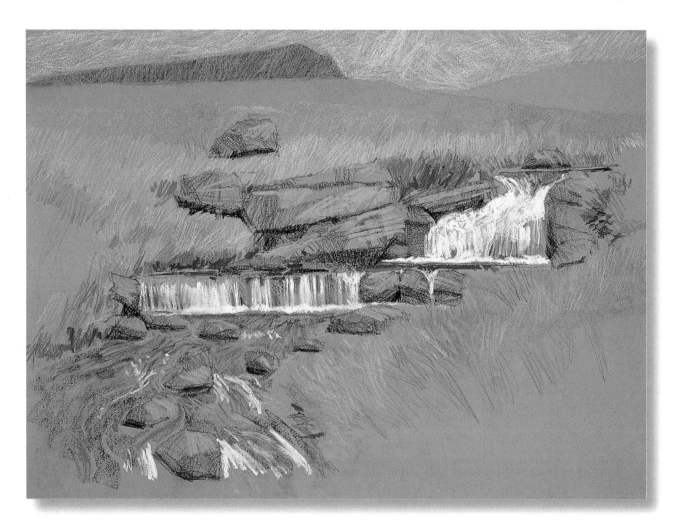

Water is an important element in the landscape, and whilst not always evident, its influence is constant and can be seen in the landscape's topography and its position deduced by the growth, or lack of growth, of vegetation.

Water is fun to draw but it does present the artist with a particular set of difficulties. Water is generally transparent – hold a glass of it up to the light and you can see through it – however, larger bodies of water have distinct colours. Colour in water occurs in three ways. Firstly, it can be coloured by minerals, salts, silt and tannins leached from the soil and the rocks. This is commonly seen in streams that run through areas rich in peat that has built up over hundreds of years, or in the run off from those areas rich in iron

or tin ores. Alternatively, colour can come from the actions of algae turning the water green as it reacts with the sunlight. Secondly, water has reflective qualities and behaves much like a mirror reflecting its immediate surroundings and any overhanging vegetation, not to mention the ever-changing colour of the sky. Lastly, the colour of the rocks and vegetation in the water add their colour to the mix.

The reflective quality of water is most noticeable in still water. Disturb the water and the reflections become broken and fragmented until they are no longer visible: this is when the sparkle and dappled shimmer of sunlight reflecting off the

water's surface is most noticeable. Fortunately, the actions of water tend to be repetitive and even with fast flowing water, as featured in this project, careful observation should enable you to make a fair representation.

When drawing water, choose your drawing media and techniques carefully. Materials and techniques that are essentially tonal rather than linear are preferable. As a general rule, when drawing water work in layers. Begin by blocking in what could be considered to be the general colour of the water together with anything that is visible beneath the surface. Draw in any surface disturbance, reflections or highlights last.

## Subject

This cold mountain stream offers ample opportunity to practise drawing fast-running water. The patterns created by the water falling over the rocks repeat themselves and although this drawing captures a frozen moment in time, the movement of the water is suggested by the slight blurring of the falling water created by smudging some of the crisp chalk marks.

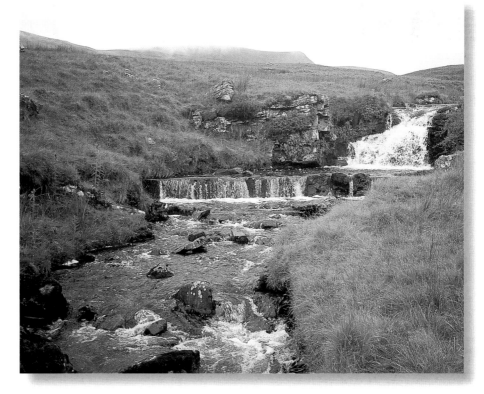

## Materials

*Sheet of light green pastel paper 380 x 545 mm (15 x 21¹/₂ in)*

*Conté sticks in white, light blue, burnt umber, brown, black, grey, violet, light green, sap green, cadmium yellow, Naples yellow, viridian green and ultramarine*

*Fixative*

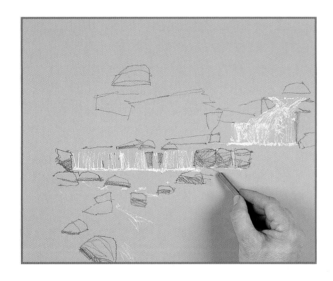

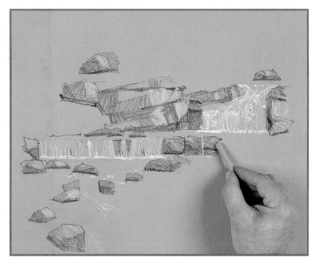

**1** Using the white Conté stick, lightly sketch in the position of the two waterfalls. Use linear strokes to suggest the angle and the fall of the water over and down the rocks. Notice the composition and how the falls are positioned diagonally across the support with the stream turning in on itself in the foreground.

**Artist's tip**
When using soft pigmented drawing materials, avoid building up too dense a layer of pigment. The work will look looser and fresher if the support is allowed to show through.

**2** A few light blue marks suggest the pale blue sky reflecting off the surface of the darker areas of water. Use the burnt umber to position the outcrop of rock over which the water cascades together with the larger rocks that litter the stream bed. Once in place, the same Conté stick is used to scribble in the local or general brown colour of each rock.

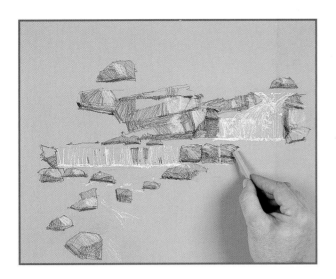

3 Work some black into the shadow around each rock and into the cracks across the rocky outcrop. Use scribbled white and grey chalk to draw the lighter side of each rock. Notice how, although simply drawn, these three colours are sufficient to suggest the rounded form of each rock. Keep the Conté work open allowing a degree of the coloured paper to show through.

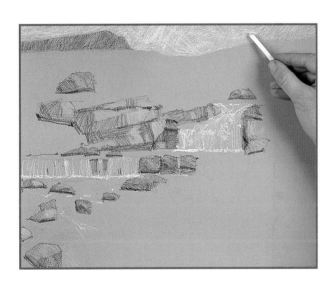

4 Violet is used to block in the distant hill. Scribble some black followed by a layer of the light grey over this. The sky is blocked in using light blue which is immediately lightened by adding a layer of white. Keep the scribbled marks open and constantly change the direction of the strokes so as not to build up marks that all run in the same direction.

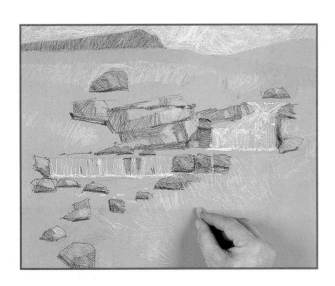

5 Work some light green in a scribbled band across the hillside above the highest outcrop of rock. Make open, linear strokes of the same colour to each side of the lower waterfall suggesting the tufts of grass and reed that surround and frame the path of the stream. Keep these strokes fine and crisp by always using a sharp edge of the stick.

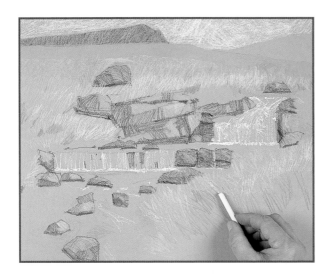

6 These areas of grass are modified by adding similar linear marks using the sap green, cadmium yellow and Naples yellow sticks. Use directional strokes to suggest the way that the grass sits on, and falls down and across, the hillside. Remember to keep the work open so that the colour of the paper shows through. Draw the darker grass and the shadows that are undercutting the edge of the water using the sap green. This is then worked over and the area darkened still further using the viridian green.

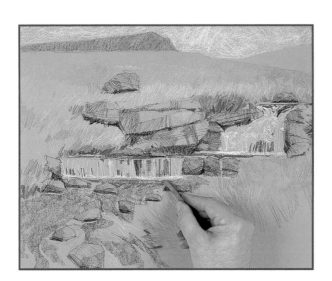

7 Use black to darken and strengthen the shadows immediately beneath each of the rocks and the deeper crevices and cracks in the rocky outcrop. Strengthen the colour of the water using ultramarine. Wide, fluid marks suggest the patterns created on the water's surface as it flows and eddies around the rocks, while heavier applications of colour are made immediately above and below the point where the water cascades over the rocks.

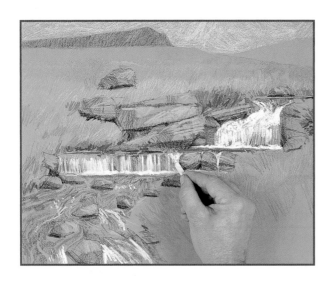

8 To complete the drawing use the grey stick to draw in the light striations running across the rocky outcrop. Use the same colour to strengthen the lighter passages on some of the rocks in the stream. Use grey to subdue the blue drawn in the stream in the previous step. Add some dashes of white into the cascade and blend them gently with your finger: a technique that gives the illusion of movement.

# TRY A DIFFERENT ...

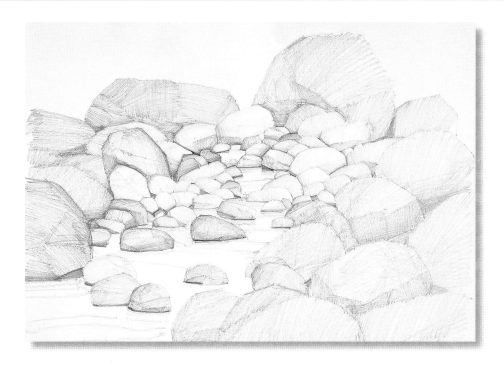

## ... MEDIUM

This simple sketch of an almost empty stream is made using a 2B graphite pencil. The rocks and boulders are given form by carefully-applied areas of tone. The tone is applied in blocks that follow the direction of the surface of each rock. Some of the pencil lines are also made to curve around the contours of the rocks in order to further sculpt their shape. A few flowing lines suggest the direction and flow of water as it makes its way around each rock.

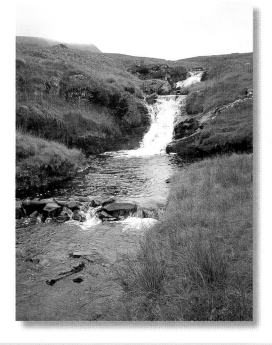

## ... VIEW

This image, although similar to the main project image, gives you the chance to make a drawing using an upright format. Try drawing on a mid-grey or light blue paper that can be used to represent the colour of the sky and its light reflected in the stream.

## Demonstration 7

# Pine forest *Fine liner*

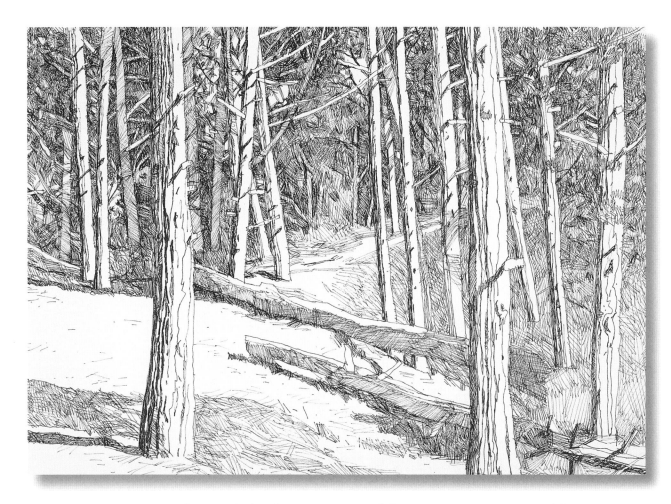

Trees are an important element in landscape drawings. They lend an important and vital vertical focus to images that tend to be constructed and read across the horizontal. Trees add colour, texture and form. They are also important compositional elements that can be used to divide the picture area up into distinct zones, direct the eye and can also be used as important focal points, trees also make great subjects in their own right.

Whilst some trees can resemble a lollipop on a stick, most grow in a wide range of different shapes and sizes which are influenced not only by the species' natural growth habits but by their growing environment. This means that trees of the same species can look very different in different places. Trees in forests tend to grow straight and high as they compete for the light whilst trees growing in more

open coastal regions with steady high winds often grow looking bent and stunted but are in fact healthy, having simply adopted their growing habit to suit the environment they are living in.

Capturing the true character of a tree is far from easy and requires a combination of acute observation and a good use of your materials. Remember that trees are living things and grow in a logical if sometimes haphazard way. This should be reflected in your drawing. Branches and leaves should not appear to be simply stuck on. Remember that beneath the leaves is an intricate skeleton of branches that give the tree its form. The closer you are to the subject the more detail will be apparent. Trees in the distance are often little more than simple shapes but close to they are complex and intricate objects covered in texture and detail and dappled with a range of tones and colours from the light that filters through the foliage.

## Subject

The dry, broken trunks of the trees in this pine forest are splashed with spring sunshine which has the effect of throwing them into sharp relief against the dark, deep interior of this ancient forest. The effect is precise and graphic and calls for a precise approach.

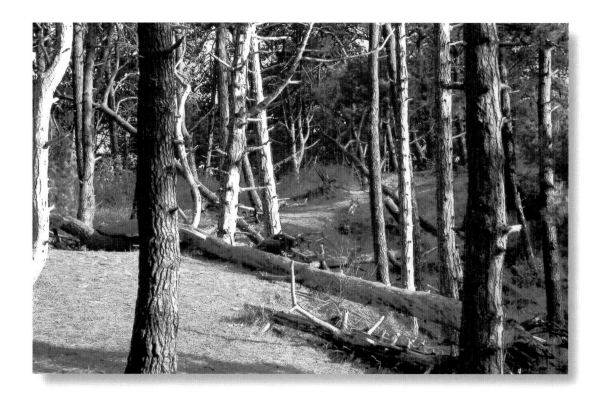

## Materials

*Sheet of white hot
pressed drawing paper
420 x 297 mm (16$\frac{1}{2}$ x 11$\frac{3}{4}$ in)*

*02 fine liner*

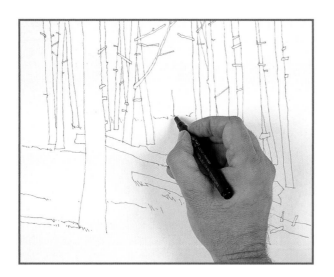

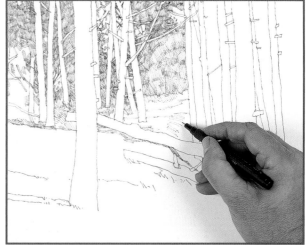

1 Carefully position all the elements
by drawing them in using the pen.
Although care should be taken, do not be
too concerned if some things are positioned
incorrectly as this can be corrected with
subsequent pen work.

2 Begin to work around the tree trunks
and the major branches using hatched
and cross hatched lines. Use directional
strokes wherever possible to suggest the
direction of branches and to make some
sense of the tangled undergrowth in the
distance. Also use directional strokes to
show the fall of the hillside upon which
the trees are growing.

3 Work into these areas further, building and darkening the tone. Allow lighter patches of tone to show where there are trunks or branches that are just barely visible deep within the undergrowth.

### Artist's tip
It is possible to vary the density of the line by varying the speed with which you make it. Used fast, less ink is delivered to the support making a lighter line.

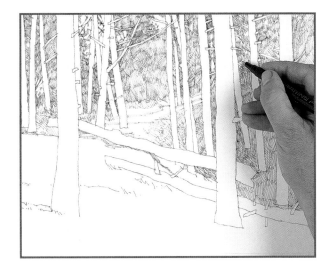

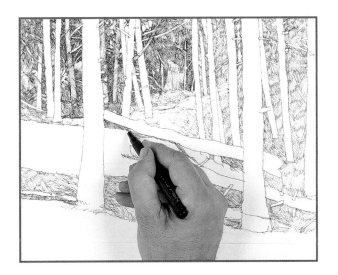

4 Continue the process, steadily darkening the tones by increasing the density of the cross hatched lines. Begin to add tone over some of the trees in the shadows and add the shadows that run diagonally across the image.

5 As the line density builds up, it becomes possible to scribble on lines in a slightly less ordered fashion. Tonal density is built up much faster this way but care needs to be taken not to overdo it. It is always easier to make an area appear darker than to make an area appear lighter.

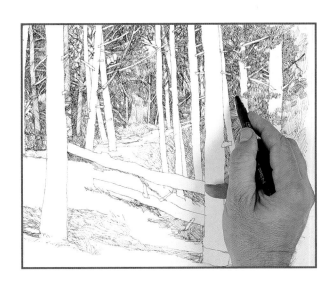

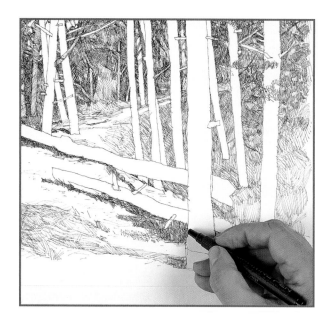

6 Add more hatching beneath the fallen trees that cut diagonally across the image, taking care to follow the contours of the ground as it falls away down the slope.

7 Detail is then added to the tree trunks. Dark pen work suggests the texture of the bark. Hatching is added to the line work on the shaded side of the tree but a simple flowing or jagged line represents the pattern of the bark that is in full sun, whilst the crisp, short shadows from the broken branches help suggest the rounded shape of the trunks.

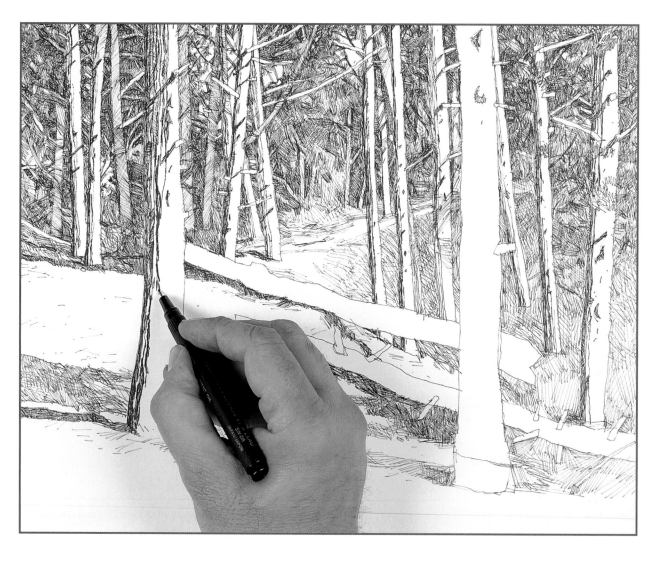

# TRY A DIFFERENT ...

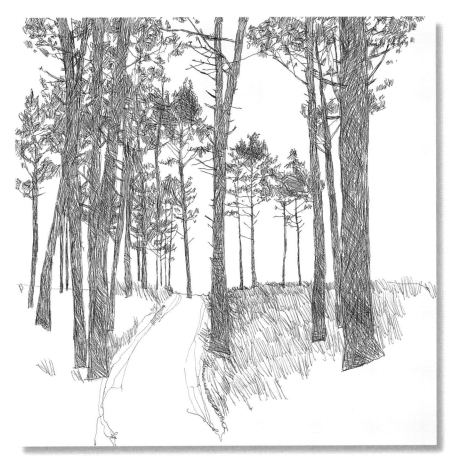

## ... MEDIUM
This stand of pines on either side of a track was drawn using a simple black biro or roller ball. The tone is achieved by knitting together a complex network of carefully scribbled lines until the correct density is achieved.

## ... VIEW
Glimpses of sky break up the dense forest canopy and offer some kind of tonal relief from the dark forest floor. Notice how the trees, although upright and straight, do not all grow at precisely the same angle.

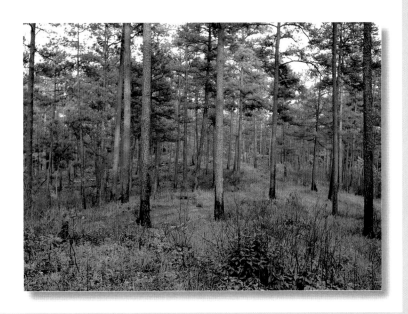

## Demonstration **8**

# Summer shore *Pen and wash*

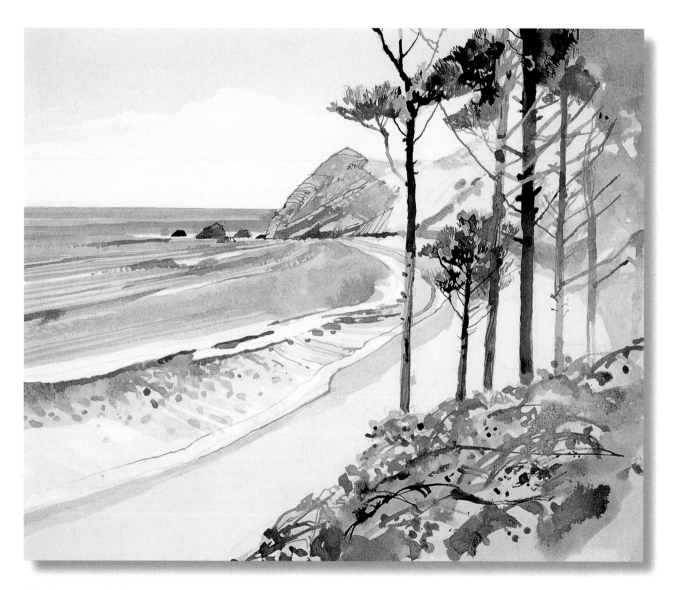

Whilst not all of us are fortunate to live in areas of outstanding natural beauty, there are always subjects worthy of the landscape artist's attention not far away. Vacation trips often provide excellent subject matter that we might not exploit there and then but turn into finished drawings much later, perhaps on our return home. In order to do this, a certain amount of information will need to be collected to act as a memory aid. Vacation trips are invariably packed into a few days or if you are really fortunate a few

weeks. In an ideal world, all of this time would be spent drawing and painting, but for many the time available might only amount to a few hours, and a complex drawing can take several hours, and not always with a guarantee of success.

People often find that working in ink can be intimidating, perhaps due to the fact that it can be difficult to remedy mistakes because of the indelible nature of the medium. To a certain extent, this can be solved by working in water-soluble ink or by planning the work before starting. A light pencil drawing to plan out the composition is always helpful. This should not be followed too closely or it might inhibit the free-flowing pen work, but should act as a guide. Any pencil lines will be obliterated by the ink and those that are not can be erased once the drawing is dry. Heavy applications of ink on thick paper can take a surprisingly long time to dry, so it is best to save erasing any marks until several hours after the drawing is finished so that the work is not spoilt. Ink can be diluted with clean water and it is perhaps best that regardless of the subject, the initial marks are made using a pale diluted ink rather than ink at full strength.

## Subject

A quiet bay provides an ideal early morning picture-making opportunity.
This scene will change dramatically once people arrive for their day at the beach.

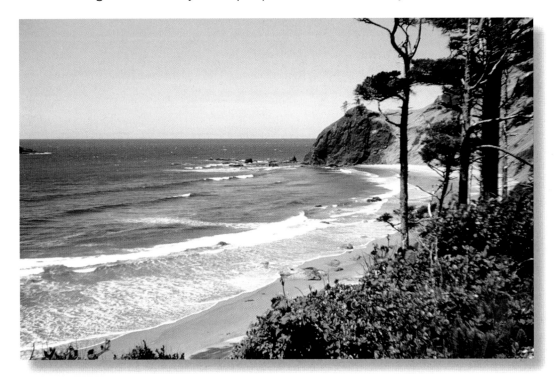

## Materials

*Sheet of Not watercolour paper*
*420 x 297 mm (16$\frac{1}{2}$ x 11$\frac{3}{4}$ in)*

*No 10 round sable brush*

*Dip pen with steel nib*

*Thick and thin reed pens*

*Black Indian ink*

*Water*

**1** If you find working in ink intimidating, begin by making a simple light pencil drawing using a soft pencil. Dilute a small amount of Indian ink in plenty of clean water and, using the sable brush, apply this pale wash to the sky, cutting out the shape of the clouds. Apply also to the sea, leaving the white paper to show through as breakers, and to the distant rocky outcrop and the beach.

**2** Darken the wash mix slightly by adding a little more Indian ink and once the first wash is dry use the second wash to apply a tone to the sea, again working around the breakers, and to the rocky headland.

3 Develop the sea by using the wide reed pen and the mix of Indian ink used in the previous step to draw in a series of roughly parallel lines that curve around the bay. These represent the slightly darker tones of the undulating swell that moves in to break on the shore. At this point, the pen is used to draw in the darker shadows that can be seen beneath the breaking waves.

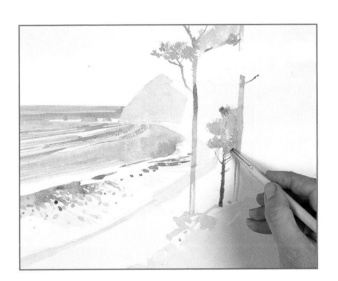

4 The same pen and mix of ink is then used to draw the stand of pines that sit high above the beach. Applying pressure to the tip of the pen will spread the nib and make a wide mark suitable for drawing in the width of the trunk, whilst using the pen on edge or by allowing only one corner of the cut end to touch the paper makes it possible to draw in thin irregular lines that represent the branches or the foliage.

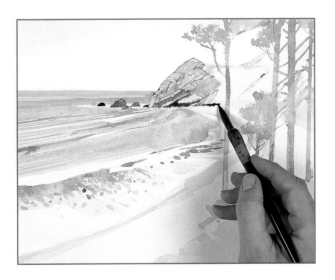

5 Darken the ink-water mix further by adding a little more ink. Then, using the steel-nibbed pen, draw in the rocks that break the surface of the water at the headland. Once the ink has been applied to the drawing the smaller of the two reed pens has been used to move it around the surface in order to create a series of denser solid marks that represent the strata of the rock.

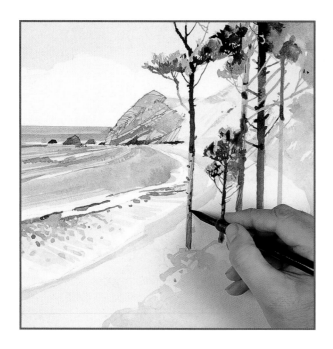

6 The thin reed pen is also used to add density to the shadows beneath the waves. It is also used to add a darker tone beneath the canopy of the trees and to parts of the tree trunks. Change to the dip pen with the steel nib and, using neat black Indian ink, work into these areas drawing in the tree bark and adding detail to the foliage.

7 Return to the thicker of the two reed pens and, using the diluted ink, complete the drawing by adding the thick tangle of brambles and foliage that can be seen at the foot of the trees.

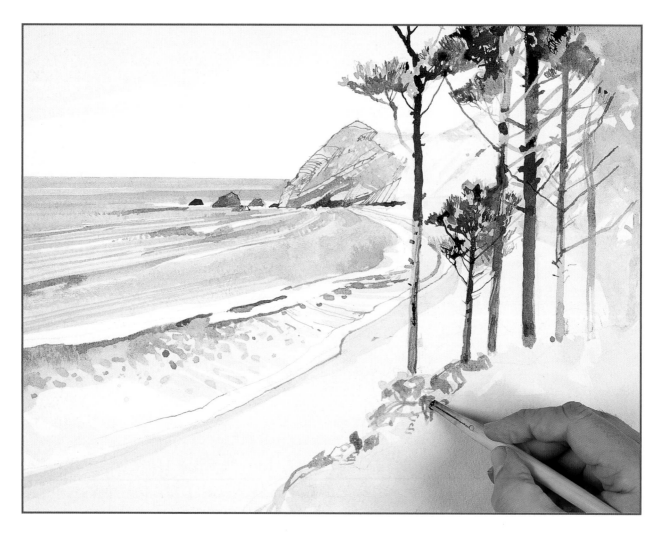

# TRY A DIFFERENT ...

### ... MEDIUM

This sketch of rocks and young umbrella pines was made using a few pastel pencils, an ideal medium for drawing on location. The drawing was made on a lightly tinted paper that supplies the basic colour for the scene. Working on tinted or coloured paper always cuts down on the actual work needed to give a drawing solidity.

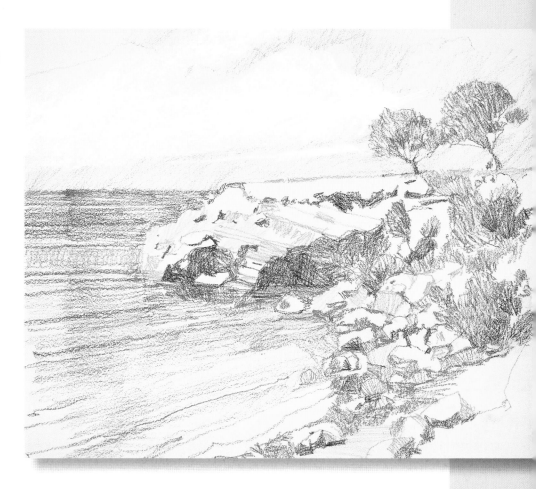

### ... VIEW

Waves crashing onto a rock-strewn shoreline makes for an ideal picture-making opportunity. At first it may look complex but remember when drawing that the rocks are stationary and do not move and the action of the sea tends to be repetitive.

# Demonstration 9

# Coastlines *Graphite sticks*

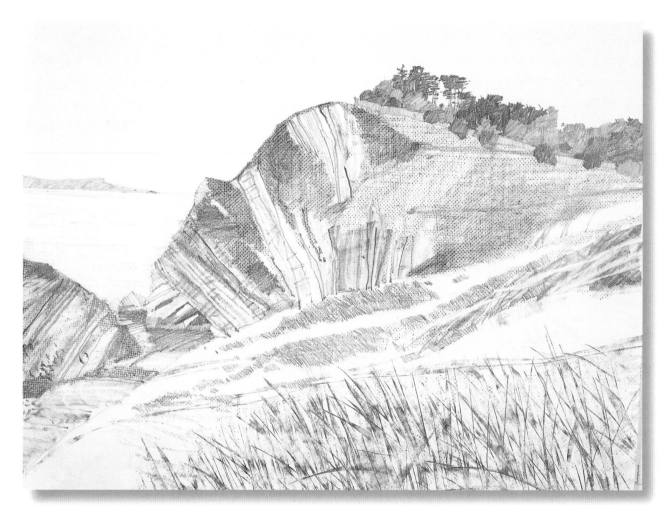

When drawing a coastline the first thing that is instantly manifest is the sense of scale. The landscape seems to open up and the huge expanse of sky and sea can seem almost overpowering. Set against this, the features of the coastline are almost always dramatic, especially in those places where the landscape ends abruptly with weather- and sea-beaten cliffs and rocky outcrops. Such places are inspirational to all and especially to the artist. The wealth and variety of textures and patterns made by the shape of eroded rocks, vegetation, smoothed pebbles, cloud formations and the constantly moving sea are overwhelming.

At first it may seem an impossible task to do such scenes justice – any drawing is in danger of falling far short of the reality.

The answer is to have fun with the subject and use those techniques and materials that work well on a larger scale and that enable a wide range of textural effects to be implemented. Frottage techniques are particularly effective when making these types of drawing and for best results, the paper needs to be relatively light-weight and smooth so that the texture of the material being used on the drawing can 'read'. Textural techniques, on the other hand, are usually more effective when carried out on rough-surfaced papers.

As with any technique, it is best to first practise on a spare sheet of paper that is the same as that being used for the drawing before starting work. This will tell you if the paper is too thick, how much pressure needs to be applied and whether or not the material being used actually creates the desired effect on the paper. You will also be able to look closely at the patterns and textures being made and decide if they can be used on the final drawing or not. It is far better to work all this out beforehand rather than risk spoiling a drawing by working directly on to it. Prepare yourself to work against the wind by securing your paper to a drawing board. Alternatively, work from small sketches and/or photographs back in the studio.

## Subject

In this photograph, the cliffs seem to have folded in on themselves. The hard rocks have created interesting strata as they were pushed skywards by volcanic action. Behind them, the softer limestone has been eroded and worn away by the action of the sea to create a sheltered cove.

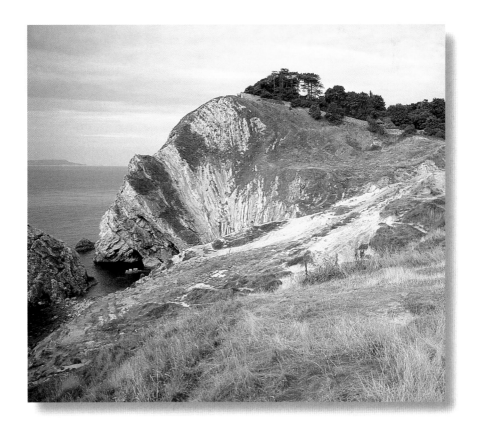

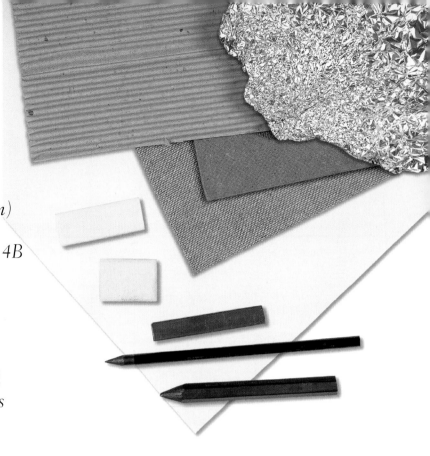

### Materials

*Sheet of thin, smooth cartridge (drawing) paper 420 x 297 mm (16¹/₂ x 11³/₄ in)*

*Graphite sticks in 2B, 3B and 4B*

*Putty eraser*

*Hard vinyl eraser*

*Canvas board, corrugated card and silver foil to create textures*

*Fixative*

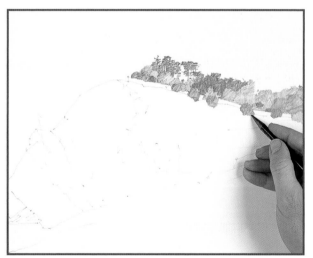

1 Use the 2B graphite stick to sketch in the position of the cliffs and the band of trees and shrubs that run along the top of the central cliff. Notice how this band takes the attention out of the picture. The eye is bought back by the pathways worn through the grass and the area of thick grass in the foreground, both of which slope into the image at a different angle to the trees.

2 Use the same graphite stick to draw in the row of trees using scribbled tone. Vary the degree of tone by using lighter or heavier pressure. A variety of directional strokes indicates the different trees especially when several trees that are the same tone are standing together.

3 Apply a light tone to the land mass seen on the horizon still using the 2B stick. Then use horizontal strokes to apply a tone to the area of sea. The horizontal strokes should become slightly darker and more apparent in the foreground. Once completed use a segment of the putty eraser to work back into the tone.

4 Take the canvas board and place it beneath the paper, then using the 3B graphite stick applied with a reasonably heavy pressure, scribble in the areas of grass. The texture of the canvas board is transferred onto the drawing. Move the board a little and rework some of the areas in order to darken them.

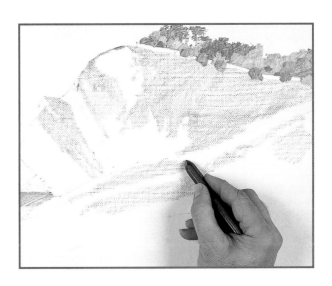

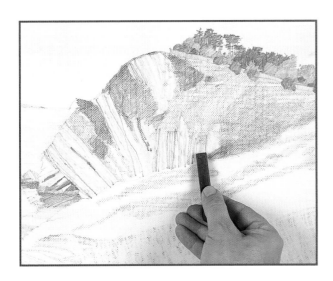

5 Use the same technique across the foreground, then work into it using the hard vinyl eraser to suggest individual blades of grass. Use a combination of the 3B graphite stick and the very soft 4B graphite stick to draw in the strata of the rock running down the cliff.

**Artist's tip**
Once you are satisfied with textural marks, spray them with fixative to prevent them from becoming smudged and indistinct whilst doing subsequent work.

**6** Use the sharp 2B graphite stick to add further detail to the rock strata. Corrugated card can also be used under the paper to add to the effect as can scrunched up and flattened silver foil. Take care when scribbling over corrugated card or foil not to apply so much pressure that you push the graphite stick into or through the paper.

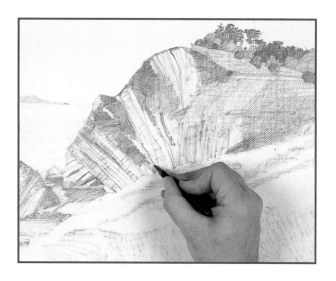

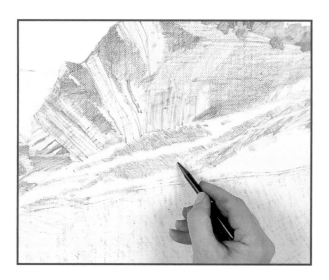

**7** Sharpen the 2B graphite stick to ensure a crisp, precise line and draw in a series of strokes to represent the banks of dry grass in the middle distance. Angle or curve the strokes gently to suggest the direction of growth.

**Artist's tip**
Frottage techniques work best on thin paper. The thicker the paper, the less successful and more indistinct the resulting marks.

**8** To complete the work, use a small piece broken from the 4B graphite stick to draw in a series of marks to the foreground. These marks also represent grass and serve to increase the feeling of space and the aerial perspective. Use the long sharp edge of the stick and vary the pressure and twist the block slightly as you make the mark. Once the drawing is completed a spray of fixative will prevent any smudging.

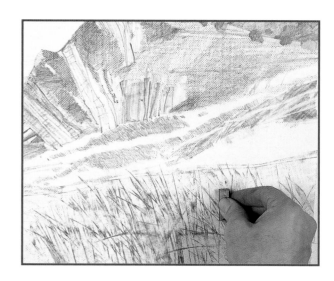

# TRY A DIFFERENT ...

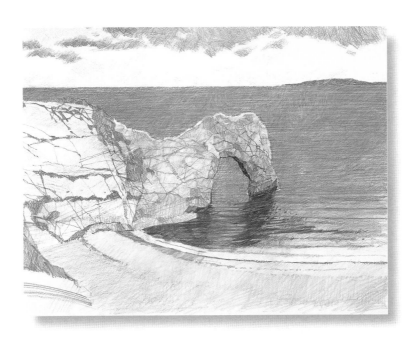

## ... MEDIUM

This dramatically eroded coastline has been drawn using pastel pencils. Coloured pencils could also have been used, but these tend to be more difficult to blend and the colour less easy to manipulate. This image was made on a sheet of white drawing paper but could also have been made on a light grey or blue paper, which would quickly establish the colour of the rocks or the sea.

## ... VIEW

This image of windswept chalk cliffs calls for a dramatic treatment. The dark silhouette of the breakwater stands stark against the pale water and the even paler cliffs. Charcoal combined with white chalk would be the ideal choice of media perhaps used on a mid- to dark-grey background.

## Demonstration 10

# Volcano and rainforest
## *Pastel pencils*

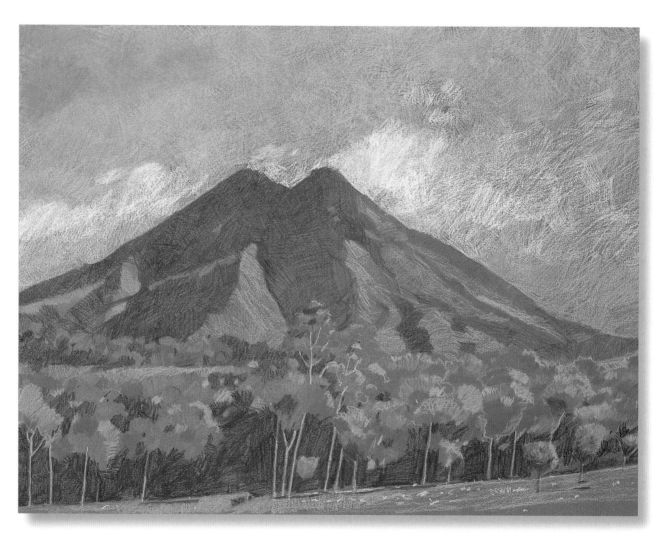

The very best and most pleasing drawings appear seamless as the subject and the drawing materials work together to create an image that is an interesting interpretation and more than just a simple copy of reality. It is for this reason that carefully matching

the subject to a specific choice of drawing material and technique can be beneficial. That is not to say that all materials cannot be used to draw all things, of course, as when used well they can. However, it does follow that certain materials and techniques suit

certain subjects more than others. Any drawing is invariably a compromise with the artist striving to make a representation of the scene but constantly aware of the restrictions of the materials being used. For this reason it is important that the artist learns what can and cannot be achieved with the chosen materials, what techniques can be used and how they behave on the chosen support.

Here, the volcano and trees have been drawn using pastel pencils on a dark brown pastel paper. As we have seen before, the use of coloured paper with pigmented drawing materials creates a distinct colour harmony. Here the colour of the paper lends a distinct solidity to the image that would be seriously lacking had the drawing been made on a white support. This image is relatively complex as the colour combinations need to be achieved using a limited palette and the shapes of the trees need definition in order to read in the drawing. The important thing to remember when using pastel pencils or any other type of coloured pencil is to keep the hatched or scribbled lines relatively open. This allows the support to show through but also allows any further colour applications to 'key' onto untouched areas of the support. If the pigment is applied too densely in the first place this cannot happen.

## Subject

Seen through a heat haze, the forested slopes of a solitary volcano tower above the surrounding landscape and provide a subject that requires some complex optical colour mixing in order to do it justice.

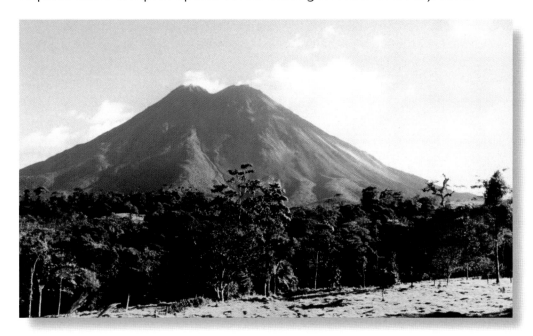

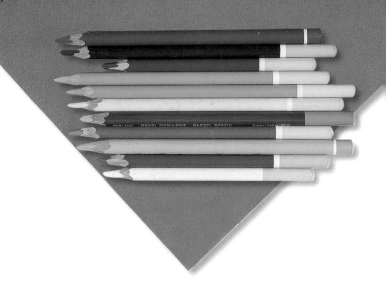

## ✎ Materials

*Sheet of dark brown pastel paper 380 x 545 mm (15 x 21½ in)*

*Pastel pencils in white, deep green, pale green, sap green, light umber, pale yellow, yellow ochre, light blue, ultramarine, indigo and violet*

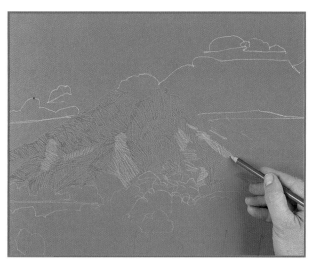

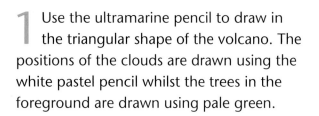

1 Use the ultramarine pencil to draw in the triangular shape of the volcano. The positions of the clouds are drawn using the white pastel pencil whilst the trees in the foreground are drawn using pale green.

2 Once the composition has been established, begin to draw in the colour of the volcano using a web of cross-hatched lines. Ultramarine is used for the areas that are in shadow with violet and light green used on the slopes that are in sunlight.

*Artist's tip*
In order to make precise, crisp marks, keep the point of the drawing tool sharp by regularly resharpening it.

3 Use white to establish the clouds and light blue to establish the colour of the sky. Smudge the light blue to consolidate the colour but rework the smudged area with more cross hatching to build up the density and the freshness of the colour.

4 The shape of the mountain stands proud against the sky and has its colour strengthened by working in more ultramarine and indigo into the shaded area with combinations of light green, yellow ochre and violet to those areas that are in full sun. Once the density of these colours has been strengthened the volcano looks more solid. The undulating sides of the volcano are described by allowing the pencil marks to follow the direction of its contours. The band of distant trees is drawn in using the three different greens.

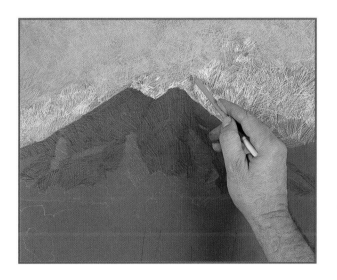

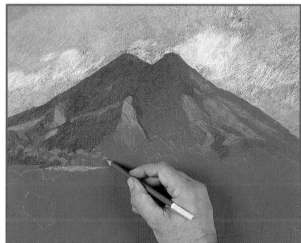

5 The forest trees are then drawn carefully. This calls for a certain degree of artistic licence. The trees appear to grow one into the other and become a solid mass and it becomes difficult to determine many of the shapes. Begin by drawing in the shape of those that you can see then work between these suggesting the shape of any further trees until the forest gradually fills with trees.

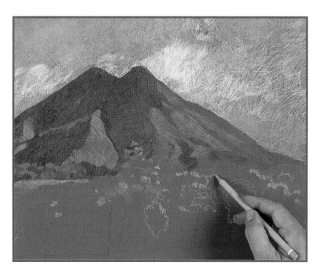

6 Use the light ochre to draw in the trunks and combinations of the three greens to represent the foliage. Keep the pastel pencil work open so that the colour of the support plays its part.

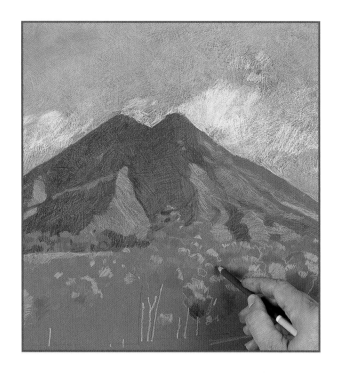

7 The forms of individual trees become more clear when indigo is used to draw in the areas between the trees that are in deep shadow. The indigo pencil is also used to draw in a few distinctly-shaped shadows cast by the smaller trees in the foreground. The drawing is completed by adding yellow ochre across the foreground with tufts and patches of dry grass picked out in pale yellow.

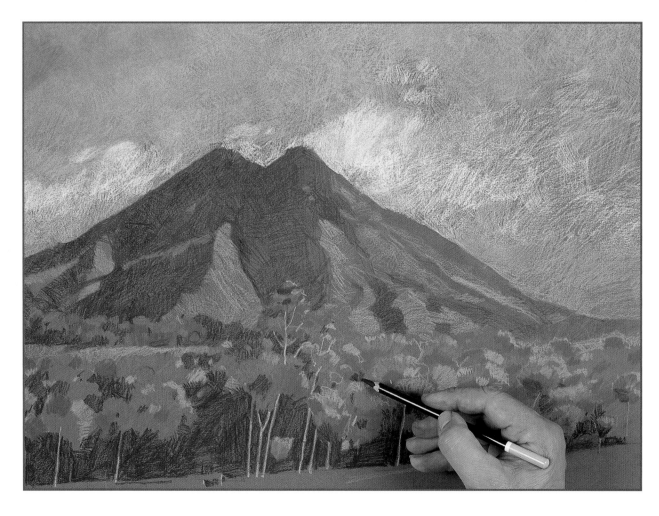

# TRY A DIFFERENT ...

### ... MEDIUM

Although this image of flat, featureless desert and sand dunes is at first sight far less complex than the demonstration image, similar considerations came into play. What treatment is suitable? Charcoal was used, scribbled over cut and torn paper masks to create the precise shaded areas and to give a distinct edge quality to the areas of tone.

### ... VIEW

When you draw these mountains, remember to give a sense of added depth and perspective by making the marks that you use to draw in the ripples and white horses on the water progressively larger as they approach the bottom of the image.

# Suppliers

**UK**

**Cass Arts**
13 Charing Cross Road
London WC2H 0EP
Tel: (020) 7930 9940
&
220 Kensington High Street
London W8 7RG
Tel: (020) 7937 6506
Website: www.cass-arts.co.uk
Art supplies and materials

**L Cornelissen & Son Ltd**
105 Great Russell Street
London WC1B 3RY
Tel: (020) 7636 1045
&
1a Hercules Street
London N7 6AT
Tel: (020) 7281 8870
General art supplies

**Cowling and Wilcox Ltd**
26-28 Broadwick Street
London W1V 1FG
Tel: (020) 7734 9556
Website: www.cowlingandwilcox.com
General art supplies

**Daler-Rowney Art Store**
12 Percy Street
Tottenham Court Road
London W1T 1DN
Tel: (020) 7636 8241
Painting and drawing materials

**Daler-Rowney Ltd**
PO Box 10
Southern Industrial Estate
Bracknell
Berkshire RG12 8ST
Tel: (01344) 424621
Website: www.daler-rowney.com
Painting and drawing materials
Phone for nearest retailer

**T N Lawrence & Son Ltd**
208 Portland Road
Hove BN3 5QT
Shop tel: (01273) 260280
Order line: (01273) 260260
Website: www.lawrence.co.uk
Wide range of art materials
Mail order brochure available

**John Mathieson & Co**
48 Frederick Street
Edinburgh EH2 1HG
Tel: (0131) 225 6798
General art supplies and gallery

**Russell & Chapple Ltd**
68 Drury Lane
London WC2B 5SP
Tel: (020) 7836 7521
Art supplies

**The Two Rivers Paper Company**
Pitt Mill
Roadwater
Watchet
Somerset TA23 0QS
Tel: (01984) 641028
Hand-crafted papers and board

**Winsor & Newton Ltd**
Whitefriars Avenue
Wealdstone
Harrow
Middlesex HA3 5RH
Tel: (020) 8424 3200
Website: www.winsornewton.com
Painting and drawing materials
Phone for nearest retailer

**SOUTH AFRICA**

**CAPE TOWN**
**Artes**
3 Aylesbury Street
Bellville 7530
Tel: (021) 957 4525
Fax: (021) 957 4507

**GEORGE**
**Art, Crafts and Hobbies**
72 Hibernia Street
George 6529
Tel/fax: (044) 874 1337

**PORT ELIZABETH**
**Bowker Arts and Crafts**
52 4th Avenue
Newton Park
Port Elizabeth 6001
Tel: (041) 365 2487
Fax: (041) 365 5306

**JOHANNESBURG**
**Art Shop**
140ª Victoria Avenue
Benoni West 1503
Tel/fax: (011) 421 1030

**East Rand Mall Stationery and Art**
Shop 140
East Rand Mall 1459
Tel: (011) 823 1688
Fax: (011) 823 3283

**PIETERMARITZBURG**
**Art, Stock and Barrel**
Shop 44, Parklane Centre
12 Commercial Road
Pietermaritzburg 3201
Tel: (033) 342 1026
Fax: (033) 342 1025

**DURBAN**
**Pen and Art**
Shop 148, The Pavilion
Westville 3630
Tel: (031) 265 0250
Fax: (031) 265 0251

**BLOEMFONTEIN**
**L&P Stationery and Art**
141 Zastron Street
Westdene
Bloemfontein 9301
Tel: (051) 430 1085
Fax: (051) 430 4102

**PRETORIA**
**Centurion Kuns**
Shop 45, Eldoraigne Shopping Mall
Saxby Road
Eldoraigne 0157
Tel/fax: (012) 654 0449

## AUSTRALIA

### NEW SOUTH WALES
**Eckersley's Art, Crafts and Imagination**
93 York St
SYDNEY NSW 2000
Tel: (02) 9299 4151
Fax: (02) 9290 1169

**Eckersley's Art, Crafts and Imagination**
88 Walker St
NORTH SYDNEY NSW 2060
Tel: (02) 9957 5678
Fax: (02) 9957 5685

**Eckersley's Art, Crafts and Imagination**
21 Atchinson St
ST LEONARDS NSW 2065
Tel: (02) 9439 4944
Fax: (02) 9906 1632

**Eckersley's Art, Crafts and Imagination**
2-8 Phillip St
PARRAMATTA NSW 2150
Tel: (02) 9893 9191 or
1800 227 116 (toll free number)
Fax: (02) 9893 9550

**Eckersley's Art, Crafts and Imagination**
51 Parry St
NEWCASTLE NSW 2300
Tel: (02) 4929 3423 or
1800 045 631 (toll free number)
Fax: (02) 4929 6901

### VICTORIA
**Eckersley's Art, Crafts and Imagination**
97 Franklin St
MELBOURNE VIC 3000
Tel: (03) 9663 6799
Fax: (03) 9663 6721

**Eckersley's Art, Crafts and Imagination**
116-126 Commercial Rd
PRAHRAN VIC 3181
Tel: (03) 9510 1418 or
1800 808 033 (toll free number)
Fax: (03) 9510 5127

### SOUTH AUSTRALIA
**Eckersley's Art, Crafts and Imagination**
21-27 Frome St
ADELAIDE SA 5000
Tel: (08) 8223 4155 or
1800 809 266 (toll free number)
Fax: (08) 8232 1879

### QUEENSLAND
**Eckersley's Art, Crafts and Imagination**
91-93 Edward St
BRISBANE QLD 4000
Tel: (07) 3221 4866 or
1800 807 569 (toll free number)
Fax: (07) 3221 8907

### NORTHERN TERRITORY
**Jackson's Drawing Supplies Pty Ltd**
7 Parap Place
PARAP NT 0820
Tel: (08) 8981 2779
Fax: (08) 8981 2017

### WESTERN AUSTRALIA
**Jackson's Drawing Supplies Pty Ltd**
24 Queen St
BUSSELTON WA 6280
Tel/Fax: (08) 9754 2188

**Jackson's Drawing Supplies Pty Ltd**
Westgate Mall, Point St
FREEMANTLE WA 6160
Tel: (08) 9335 5062
Fax: (08) 9433 3512

**Jackson's Drawing Supplies Pty Ltd**
108 Beaufort St
NORTHBRIDGE WA 6003
Tel: (08) 9328 8880
Fax: (08) 9328 6238

**Jackson's Drawing Supplies Pty Ltd**
Shop 14, Shafto Lane
876-878 Hay St
PERTH WA 6000
Tel: (08) 9321 8707

**Jackson's Drawing Supplies Pty Ltd**
103 Rokeby Rd
SUBIACO WA 6008
Tel: (08) 9381 2700

## NEW ZEALAND

### AUCKLAND
**The French Art Shop**
33 Ponsonby Road
Ponsonby
Tel: (09) 376 0610
Fax: (09) 376 0602

**Takapuna Art Supplies Ltd**
18 Northcote Road
Takapuna
Tel/Fax: (09) 489 7213

**Gordon Harris Art Supplies**
4 Gillies Ave
Newmarket
Tel: (09) 520 4466
Fax: (09) 520 0880
&
**31 Symonds St**
Auckland Central
Tel: (09) 377 9992

**Studio Art Supplies**
81 Parnell Rise
Parnell
Tel: (09) 377 0302
Fax: (09) 377 7657

### WELLINGTON
**Affordable Art**
10 McLean Street
Paraparaumu Beach
Tel/Fax: (04) 902 9900

**Littlejohns Art & Graphic Supplies**
170 Victoria Street
Tel: (04) 385 2099
Fax: (04) 385 2090

**G. Websters & Co. Ltd**
44 Manners Street
Tel: (04) 384 2134
Fax: (04) 384 2968

### CHRISTCHURCH
**Brush & Palette Artists Supplies Ltd**
50 Lichfield Street
Christchurch
Tel/Fax: (03) 366 3088

**Fine Art Papers**
200 Madras Street
Tel: (03) 379 4410
Fax: (03) 379 4443

### DUNEDIN
**Art Zone**
57 Hanover St
Tel/Fax: (03) 477 0211
Website: www.art-zone.co.nz

**PICTURE CREDITS**
ARS, USDA: 35.
FWS: 59.
NOAA: 31, 61, 73, 77.

# Index

**B**
ballpoint pen/biro 9, 10
  project using 59
blending 12

**C**
camera 17
Carré sticks 7
chalks 7, 8, 9, 25
  projects using 29, 30–34, 42–46
charcoal 6, 8, 10, 12, 19, 25
  projects using 23, 41, 42–46, 77
charcoal pencil 6
  project using 36–40
clouds, to draw 37–39, 45, 75
Coastlines 66–71
colour 30–31
  to add 13
  in aerial perspective 15, 19
  limited palette 29, 30, 73
  optical mixing 31, 73
  of water 48–49
coloured pencil 7
  project using 24–28
composition 14–15, 16, 32, 37, 44, 61
Conté sticks 7, 10, 12
  project using 48–52
cross-hatching 9, 12, 33, 38, 56, 74, 75

**D**
depth see perspective
Distant peaks 30–35
drawing board 9, 17

**E**
easel 9
erasers 8, 11, 17
  as drawing implement 11, 22, 45, 47, 69
Euclid 14

**F**
Fields and trees 18–23
fine liner 10, 11, 12, 17
  project using 54–58
fixative 7, 8, 43, 45, 46, 69, 70
focal point 54
form, to describe 12, 53
format 14, 16, 24, 37, 53
frottage 13, 67, 69, 70

**G**
golden section 14
graphite pencil 6, 10, 12, 17, 25
  projects using 18–22, 53
graphite sticks 6, 17
  projects using 35, 66–70
  water-soluble 41

**H**
hatching 9, 12, 33, 38, 56, 58
horizon line 15, 20

**I**
ink 8
  diluted 11, 13, 47, 61, 62
  water-soluble 61

**L**
light 10
  direction of 25
  reflected 40, 43, 50, 53
lighting conditions 37
line 7, 10–11
location, to work on 17, 25

**M**
marks, to vary 10–11, 57
masking 13, 22, 77
Mountains and cliffs 24–29
movement, to suggest 49, 52

**O**
optical mixing 31, 73

**P**
paper 9, 11
  for textural techniques 13, 67
  texture of 9, 11, 13, 29, 43, 67
  toned 32, 42–43, 47, 53, 65, 71
pastels 7
  pencils 7, 9, 10, 12, 46
  projects using 29, 30–34, 65, 71, 72–76
pen and ink 11, 12
  project using 47
pen and wash: project 60–64
pencils: artist's 7
  charcoal 6; project using 36–40
  coloured 7; project using 24–28
  graphite 6, 10, 12, 17, 25; project using 18–22
  pastel 7, 9, 10, 12; projects using 46, 65, 72–76
pens 8–9
  see also pen and ink; pen and wash
perspective 14, 15, 18, 28, 34
  aerial 15, 18–19, 23, 30, 31, 37, 70
  linear 15, 23
Pine forest 54–59

**R**
recession see perspective
rocks, to draw 53, 70
roller ball: project 59
rule of thirds 14

**S**
scribbling 12, 13
shade/shadow 10, 26, 33, 34, 47, 51, 52, 57, 58, 74, 76
shading see tone
sharpening 6, 7, 8, 39
sketchbook 9, 17
sketches/sketching 17, 41
  thumbnail 16
Skies 36–41
smudging, to avoid 40
stippling 12
straight edges 13
stump 8, 12, 31
subject, to decide 16
Summer shore 60–65
supports see paper

**T**
technical pen 9, 10, 12
textural techniques 11, 67
texture: of paper 9, 11, 13, 29, 43, 67
  to suggest 9, 10, 11, 47, 58
  see also frottage
thumbnail sketches 16
tonal density 57
tonal drawing 20, 27
tone 9, 11, 12–13, 19
  to add 13
  in aerial perspective 15, 19
  to balance 42
  to blend 12
  to block in 7, 45
  to build up 38, 57
  density of 12
  light 27
torchon see stump
trees, to draw 54–55

**V**
vanishing point 15
viewfinders 14–15
Volcano and rainforest 72–77

**W**
wash, ink 13, 62
wash techniques 13
water, to draw 48–49
watercolour 13
Waterfall 48–53
Winter landscape 42–47